Introduction

Packaging is the ultimate product promotion. Well-designed packaging supports impulse buying: A good package will entice a consumer to buy something they might not necessarily want or need. But there are a lot of well-designed packaging programs out there. To be successful, a designer needs to create something not only good, but out of the ordinary, simply put, extraordinary. Maybe it is an eye-catching design in a traditionally somber section, like fluorescent bottles in the syrup section. Maybe it is something more sedate in a normally colorful section, like a brown kraft bag in the chips section. Maybe it is radically a new shape, like canisters in the often boxy tea section. There is much to consider, but the designs in this book have taken all the factors into consideration and created successful packaging systems.

From bottles to bags to boxes, you will be able to find a large variety of shapes and sizes of packaging in these pages—sure to get your creative juices flowing. It is an important reference guide not only for the designer, but for the client as well, and will send you on the road to success.

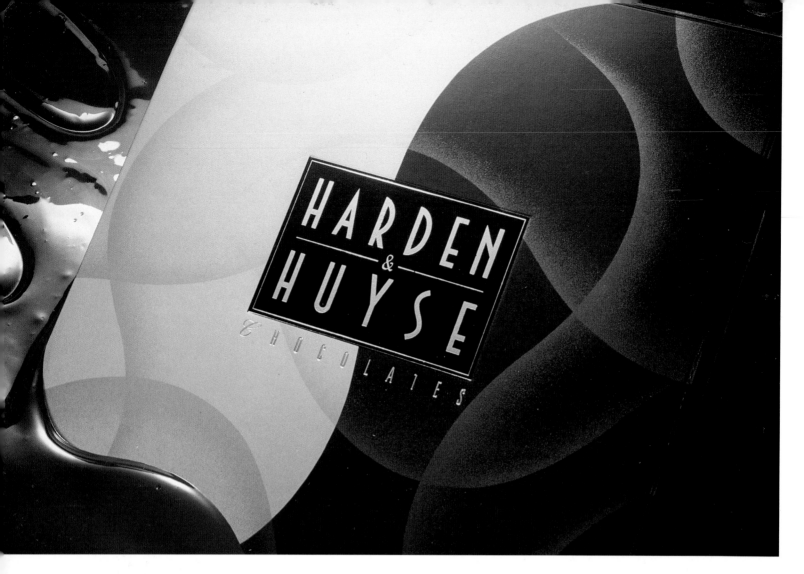

DESIGN FIRM Primo Angeli Inc.

ART DIRECTOR Primo Angeli, Carlo Pagoda

DESIGNER Philippe Becker

CLIENT Harden & Huyse

PRODUCT Chocolates

*This design establishes an exclusive, high-end image for the
brand on the same level with top international chocolatiers.
The design's subtle, melting chocolate-colored swirls communicate
a mouth-watering, but refined, taste appeal highlighted by the brand
name in elegant gold lettering. Modular containers were designed
for both display and cost-effective shipping.*

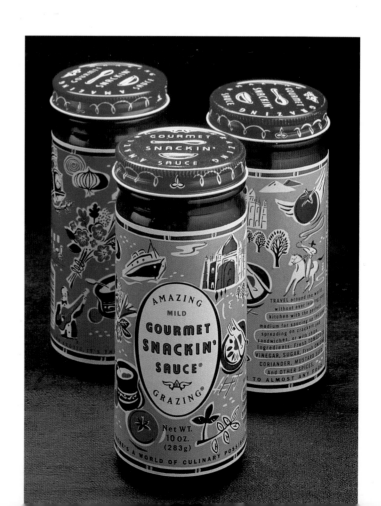

DESIGN FIRM Haley Johnson Design Company

DESIGNER/ILLUSTRATOR Haley Johnson

CLIENT Amazing Grazing

PRODUCT Gourmet Snackin' Sauce

TECHNIQUE Flexography

*This package focuses on the blending of international flavors
used to create the sauce. Icons from around the world are used
to suggest an international experience of snacking around the globe.
The colorful labels are accompanied by custom printed lids.*

More
PACKAGING

ROCKPORT
PUBLISHERS

ROCKPORT PUBLISHERS
GLOUCESTER, MASSACHUSETTS

First published in the United States of America by:
Rockport Publishers, Inc.
33 Commercial Street
Gloucester, Massachusetts 01930-5089
Telephone: (978) 282-9590
Facsimile: (978) 283-2742

Distributed to the book trade and art trade in the United States by:
North Light Books, an imprint of
F & W Publications
1507 Dana Avenue
Cincinnati, Ohio 45207
Telephone: (800) 289-0963

Other Distribution by:
Rockport Publishers, Inc.
Gloucester, Massachusetts 01930-5089

ISBN 1-56496-541-4

10 9 8 7 6 5 4 3 2 1

Layout: SYP Design & Production
Cover Images (clockwise from top left): See pages 46, 15, 48, 7, 43

Manufactured in China

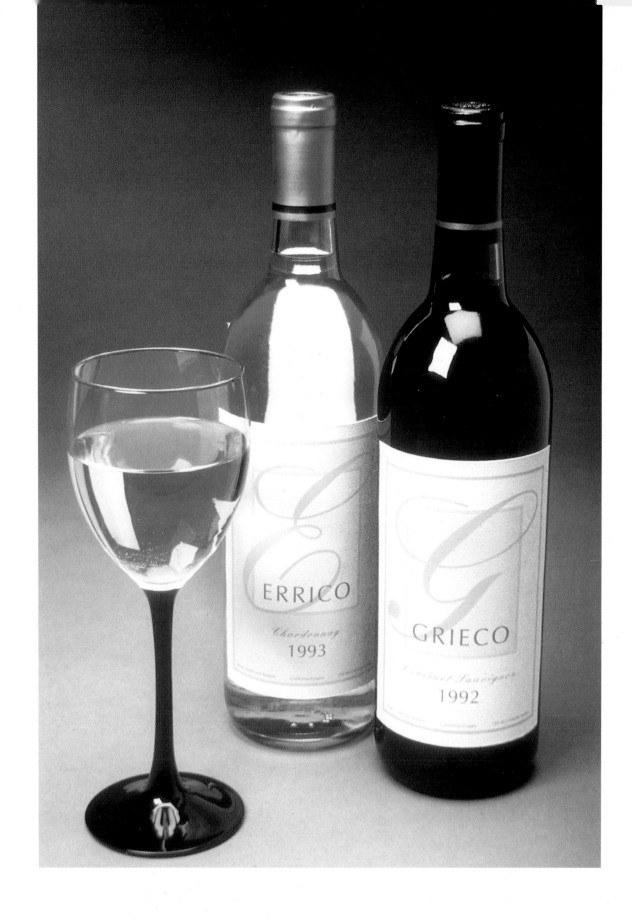

Errico Wines Label

DESIGN FIRM Platinum Design, Inc.

DESIGNER Pernilla Nilsson

ART DIRECTORS: Ava Schlesinger, Victoria Peslak

For this label, one PMS color was used with a tint and no bleed for an inexpensive print job of less than 500 labels in total. Uncoated paper was used so there was no need for varnish, and the client did his own assembly.

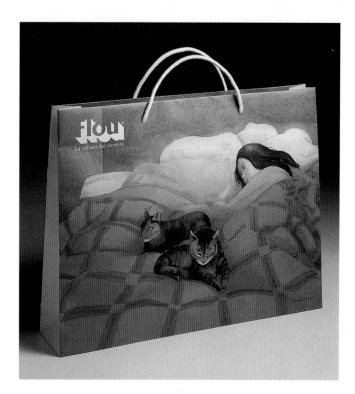

DESIGN FIRM Angelo Sganzerla
ART DIRECTOR Angelo Sganzerla
DESIGNER Angelo Sganzerla
ILLUSTRATOR Milton Glaser
CLIENT/STORE Flou

Created for Flou's bed-linen department, the artwork began as a watercolor drawing.

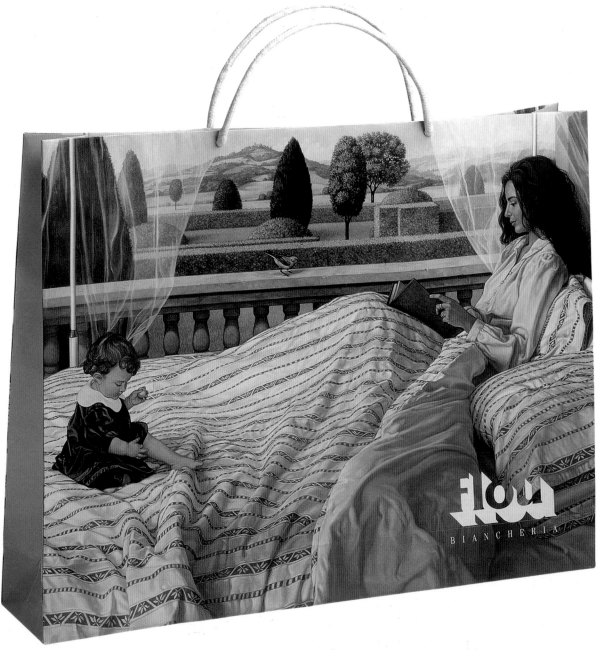

DESIGN FIRM
Angelo Sganzerla
ART DIRECTOR
Angelo Sganzerla
DESIGNER
Angelo Sganzerla
ILLUSTRATOR
Marco Ventura
CLIENT/STORE
Flou

Created for the bed-linen department of Flou, the artwork began as an oil painting on cotton cloth.

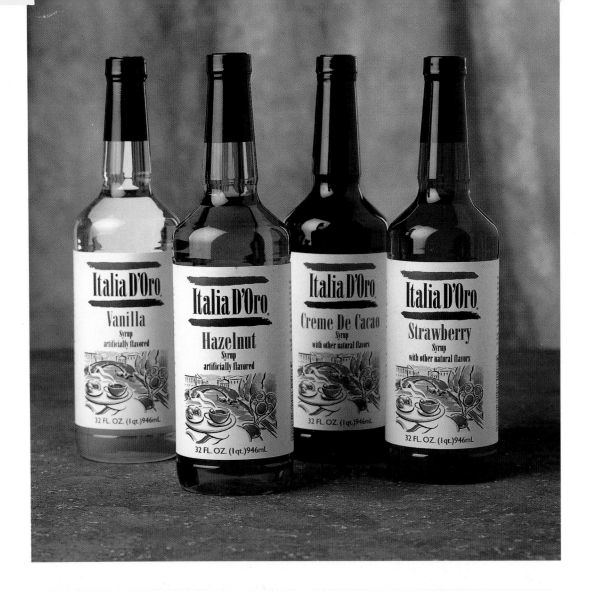

DESIGN FIRM
Robert Bailey Incorporated
CREATIVE DIRECTOR
Robert Bailey
ART DIRECTOR/DESIGNER
Dan Franklin
ILLUSTRATOR
Katie Doka
CLIENT
Boyd Coffee Company
PRODUCT
Flavored syrups
TECHNIQUE
Flexography

Flavored syrups are part of traditional Italian feasts and celebrations. Italia D'Oro is a logo and brand identity redesign to support the product upscale acceptance. It was designed in Macromedia FreeHand and illustrated by hand.

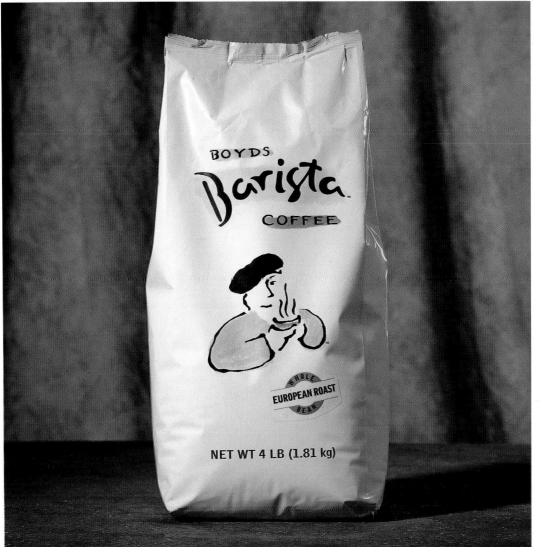

DESIGN FIRM
Robert Bailey Incorporated
CREATIVE DIRECTOR
Robert Bailey
ALL DESIGN
Dan Franklin
CLIENT
Boyd Coffee Company
PRODUCT
Coffee
TECHNIQUE
Flexography

Boyd's Barista coffee is like the chef's cut of coffee. This design was great for the flamboyant Barista, introduced in November 1995. The product is setting sales records. The packaging was designed and illustrated in Macromedia FreeHand.

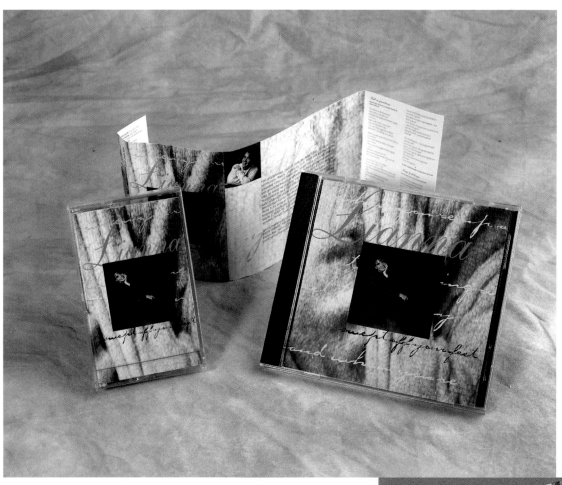

Lianna, Swept off Your Feet CD Package

DESIGN FIRM Kelman Design

DESIGNER Keli Manson

ART DIRECTOR Keli Manson

PHOTOGRAPHER Andrew W.R. Simpson

*The client was an independent artist looking to be
signed. To keep costs down only two colors were used
and the compact disc is only one color. Type is a
regular font that altered in illustration: The photographs
and type will be used for posters and displays.*

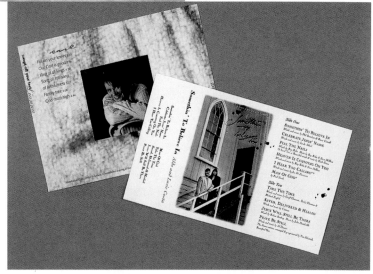

Aldo and Lucie Costa, Something to Believe In CD Package

DESIGN FIRM Kelman Design

DESIGNER Keli Manson

ART DIRECTOR Keli Manson

PHOTOGRAPHER Demy Romeo

*The project is only two-color, two-panel, J-card. The photograph was two-toned
and vignetted for interest. Hand-lettering is done by the designer, and the
photographs are kept on file for future use.*

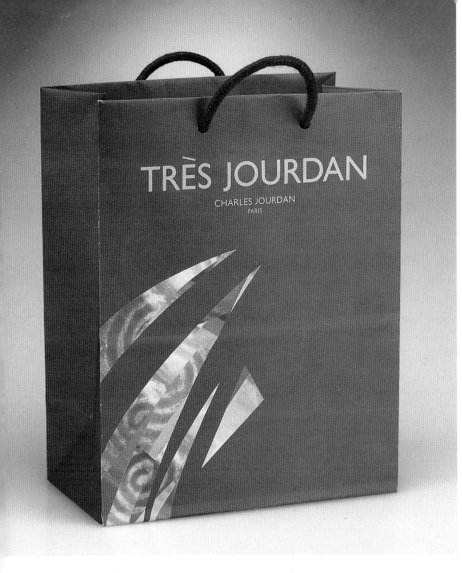

CLIENT/STORE
Muelhens Inc.
BAG MANUFACTURER
PSPCO/12:34
Ltd./Korus

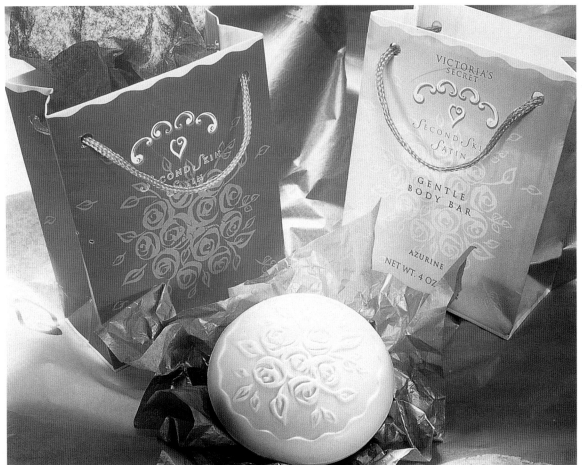

DESIGN FIRM
Desgrippes
Gobé and Associates
ART DIRECTOR
Phyllis Aragaki
DESIGNER
Marion Cledat
ILLUSTRATOR
Marion Cledat
CLIENT/STORE
Victoria's Secret/Second
Skin Satin
BAG MANUFACTURER
Pak 2000
PAPER/PRINTING
Matte-oriented
polypropylene

These miniature shopping bags were specially designed for Victoria's Secret Second Skin Satin fragrance, soap, and bath products. Because their size works so well with the soaps, the bags almost become the packaging itself.

Mezcal Avila Packaging

DESIGN FIRM Luis Fitch Diseño
ALL DESIGN Luis Fitch
PHOTOGRAPHER Mark Steele

Whenever possible, natural recyclable materials were used for this package design. All bottles were hand-wrapped with inexpensive maguey fibers made by local artisans. The label was printed on cheap recycled paper in one color.

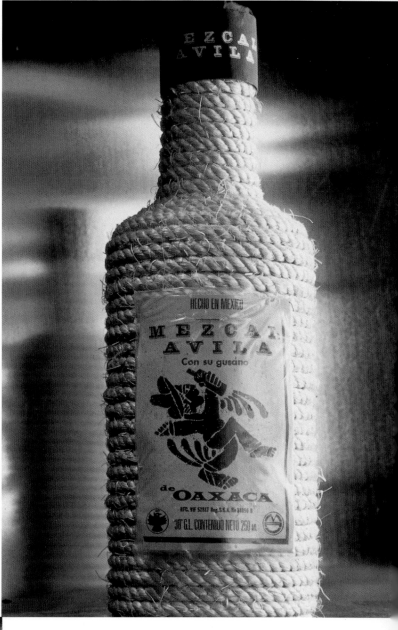

Tabaco Ornelas

DESIGN FIRM Luis Fitch Diseño
ALL DESIGN Luis Fitch
PHOTOGRAPHER Paul Brown

The cigar box was made from a non-endangered tree species found in the jungles of the Chiapas, Mexico. The package was printed in Mexico on recycled paper.

Jabon Natural Packaging

DESIGN FIRM Luis Fitch Diseño
ALL DESIGN Luis Fitch
PHOTOGRAPHER Paul Brown

To stay within the budget, the package was handmade and manufactured in one color.

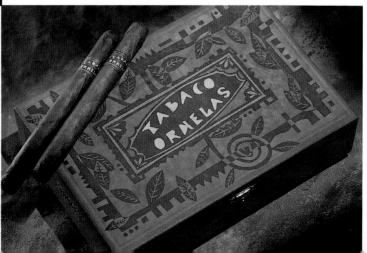

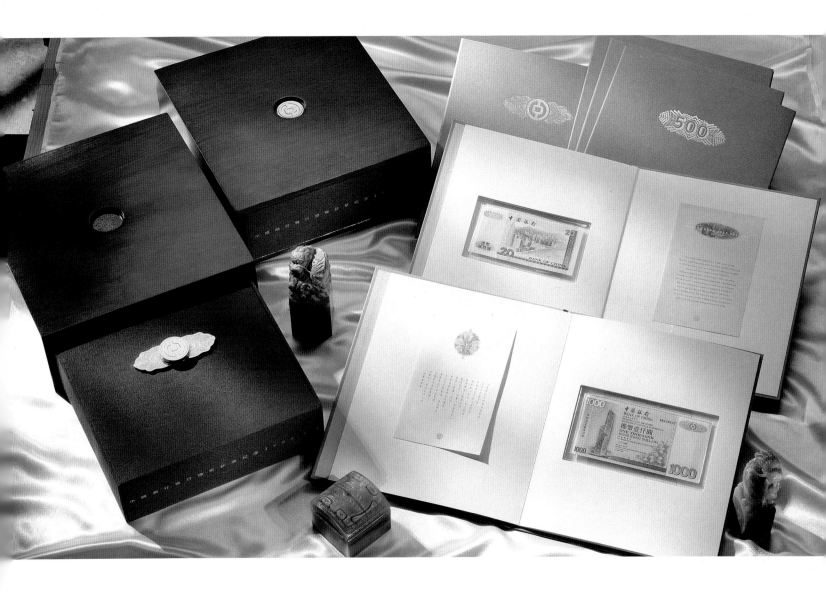

DESIGN FIRM Kan Tai-keung Design & Associates Ltd.

ART DIRECTORS Kan Tai-keung, Freeman Lau Siu Hong, Eddy Yu Chi Kong

DESIGNERS Kan Tai-keung, Freeman Lau Siu Hong, Eddy Yu Chi Kong, Joyce Ho Ngai Sing, Janny Lee Yin Wa

CLIENT Bank of China

OBJECTIVE

To design an elegant and collectible commemorative set of new currency notes for a bank

INNOVATION

Derived from a vintage Chinese design for book containers, the novel outer box is made of peachwood, a material commonly used for furniture. It houses an inner box of cloth-covered paper with a copper clasp on top that secures it to the outer container. The aesthetic enhances the practical with the addition of six albums that hold the newly-issued notes and corresponding certificates.

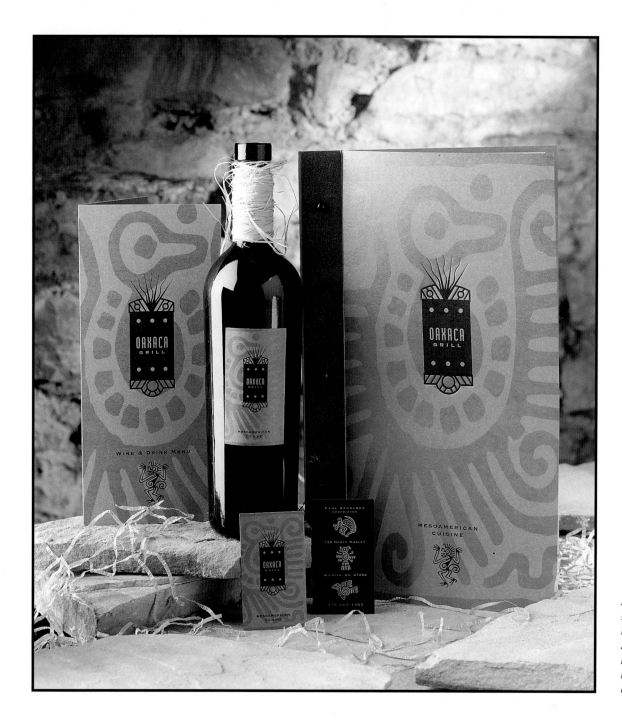

Zapotec Indian symbols, copper imprinting, embossing, and weathered metal bindings with rivets help create a feel of Old Mexico.

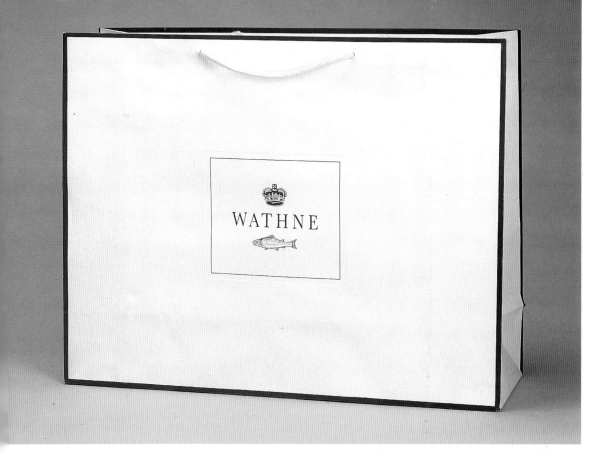

DESIGN FIRM
Wathne
CLIENT/STORE
Wathne
BAG MANUFACTURER
ModernArts production facility,
El Salvador
PAPER/PRINTING
1-color; embossed;
debossed; 80 lb. white cover stock

Wathne uses two bags: the everyday bag is printed in green, and the Christmas bag is printed in gold.

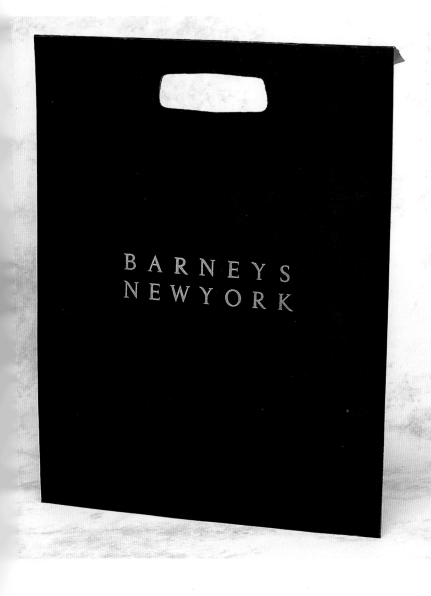

DESIGN FIRM
Donovan & Green
ART DIRECTOR
Michael Donovan
DESIGNER
Michael Donovan
CLIENT/STORE
Barneys New York
BAG MANUFACTURER
ModernArts production
facility, United States
PAPER/PRINTING
Heat-stamping

These bags are printed on heat-stamped, pigskin-embossed paper.

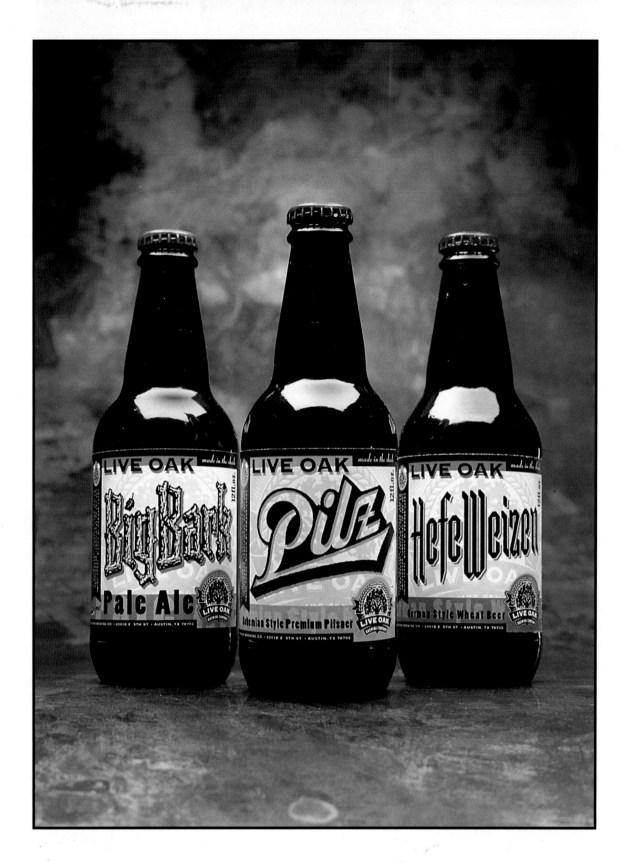

CLIENT

Live Oak Brewing Company Austin, Texas

CLIENT CONTACT

Chip McElroy, Brian Peters Proprietors

DESIGN FIRM

Kampa Design
Austin, Texas

ART DIRECTOR

David Kampa

DESIGNER

David Kampa

ILLUSTRATOR

David Kampa

Three beers, each with its own iden-
tity, benefit from the overall brand
approach of Live Oak Brewery.

A singular look to the labels serves
as backdrop for unique product
lettering. Beer name and label color
are the only design elements that
change.

The handcrafted lettering for the
Bohemian-style pilsner refers to Art
Nouveau motifs; the German-style
brew likewise has appropriate
lettering, where the pale ale
approach is more whimsical.

DESIGN FIRM Louise Fili Ltd.

ART DIRECTOR/DESIGNER Louise Fili

CLIENT Grafton Goodjam

PRODUCT Vinegar

TECHNIQUE Offset

This was a new lower-priced line of gourmet vinegars produced by Grafton Goodjam. An old photograph was used to give the company a more personal identity.

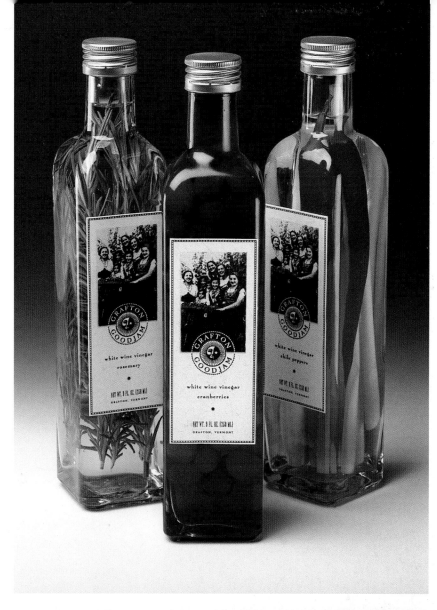

DESIGN FIRM Louise Fili Ltd.

ART DIRECTOR/DESIGNER Louise Fili

CLIENT Picholine

PRODUCT Olives

TECHNIQUE Offset

Picholine olives are sold in a restaurant of the same name in New York City. The label features the restaurant logo and graphics.

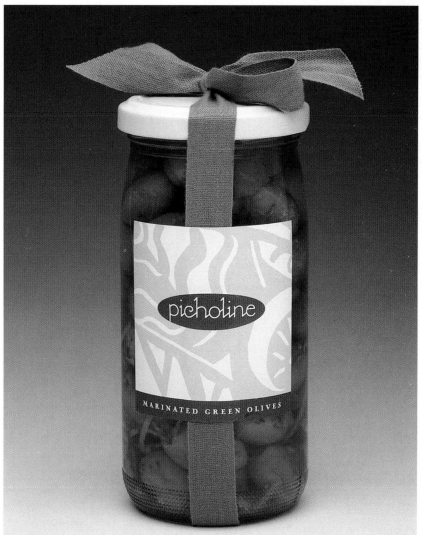

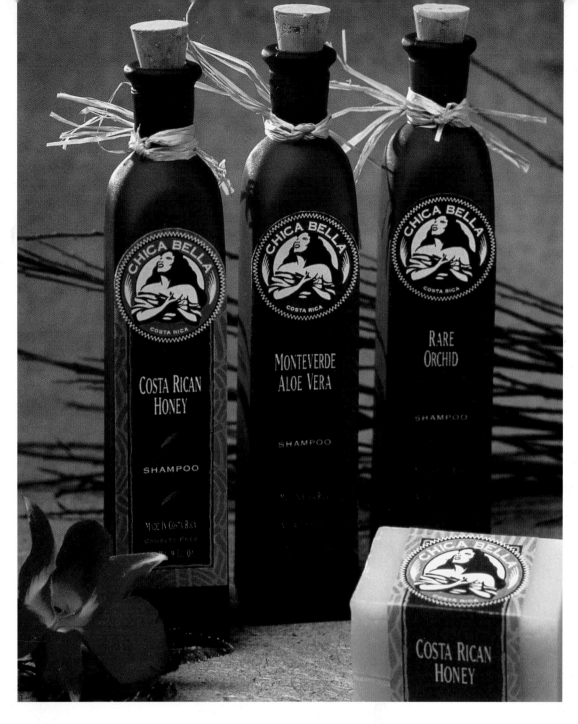

DESIGN FIRM
Greteman Group
ART DIRECTOR
Sonia Greteman
DESIGNER
Sonia Greteman
CLIENT
Chica Bella
PRODUCT
Natural beauty products

This line of Chica Bella natural beauty products is sold in health food stores and was designed to echo the colors and patterns of nature. Each product line encompasses an appropriate feeling of imagery to the botanical composition. It was created in Macromedia FreeHand.

DESIGN FIRM Malik Design
ALL DESIGN Donna Malik
CLIENT Franco Manufacturing
PRODUCT Kitchen linens
TECHNIQUE Offset

Adobe Photoshop and Macromedia FreeHand were used to create a distinctive hang tag/header card for a new line of kitchen linens (towels, pot holders, placemats, curtains, and so on).

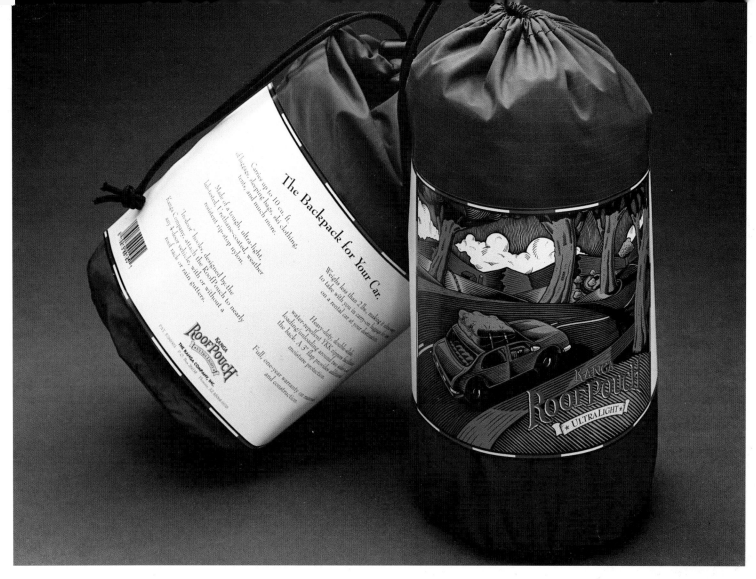

DESIGN FIRM After Hours Creative

ART DIRECTOR/DESIGNER After Hours Creative

ILLUSTRATOR Bob Case

CLIENT Kanga Company

PRODUCT Roof Top travel cover

TECHNIQUE Offset

Designed to appeal to the outdoorsy crowd, the Roof Top packaging uses a friendly, wood-cut style to reinforce the product's simplicity. Showing the product in use makes this unusual product immediately understandable.

DESIGN FIRM Greteman Group

ART DIRECTOR Sonia Greteman

DESIGNER James Strange

ILLUSTRATOR C.B. Mordan, Sonia Greteman

CLIENT Hayes Company

PRODUCT Flower & Herb Garden

An ornate English garden was the inspiration for this natural wood flower box. The engraved original illustration is hand-tinted and depicts the actual flowers in the garden. All art was created in Macromedia FreeHand.

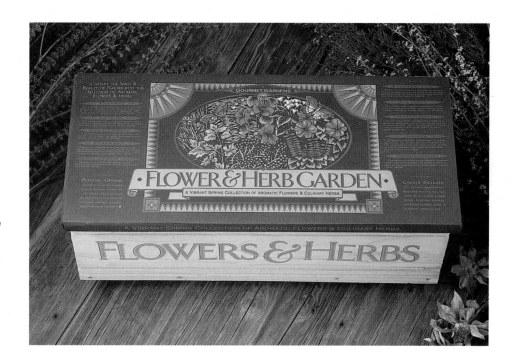

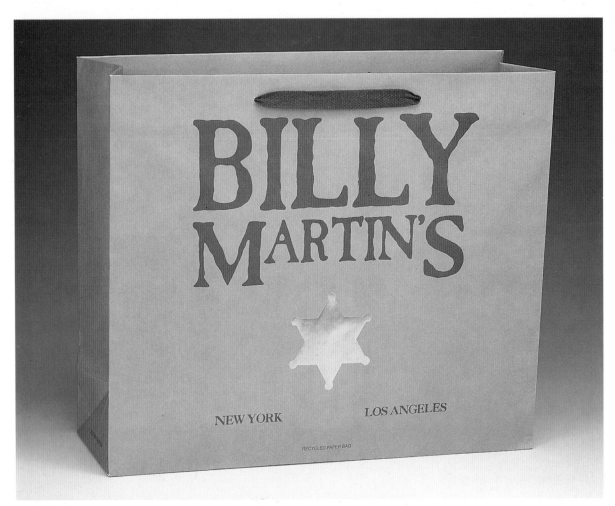

DESIGN FIRM
American Designs
in Graphics
DESIGNER
Amir Achitoov
CLIENT/STORE
Billy Martin's
BAG MANUFACTURER
Keenpac North
America Ltd.
DISTRIBUTOR
ZT Merchandising

CLIENT/STORE Paul Stuart
BAG MANUFACTURER Keenpac North America Ltd.
DISTRIBUTOR ZT Merchandising

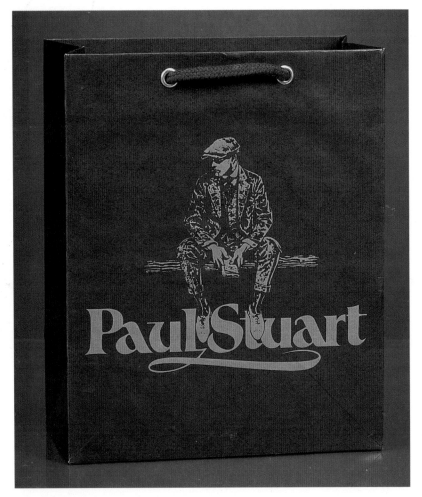

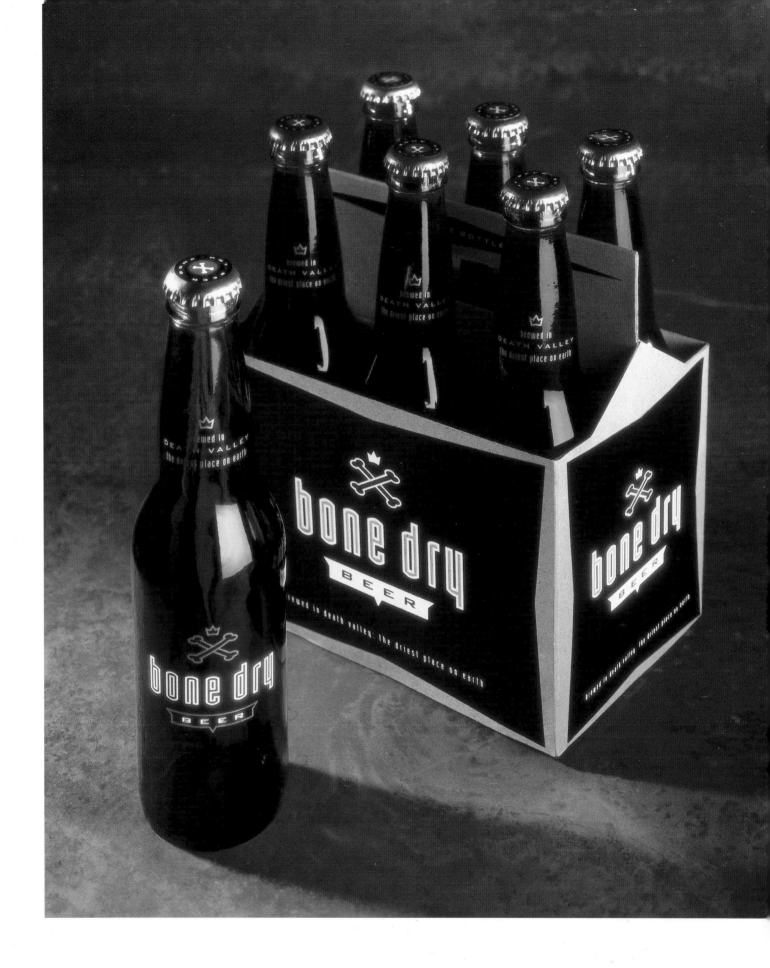

Bone Dry Beer Logo and Packaging

DESIGN FIRM Margo Chase Design

DESIGNERS Anne Burdick, Wendy Ferris

ART DIRECTOR Margo Chase

The colored glass of this bottle changes from a deep ruby red when full of beer to a bright royal purple when empty. A simple 2-color silk-screen in gold and white along with simple black and white graphics on natural kraft carriers made this design distinctive.

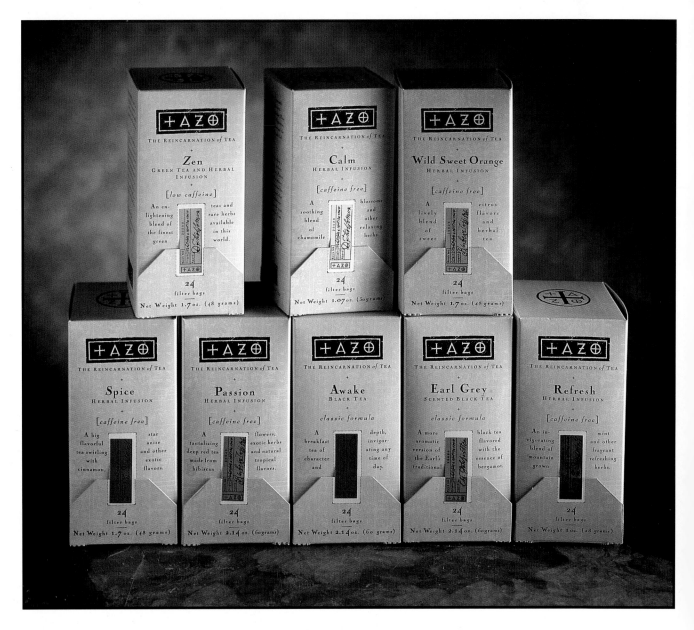

DESIGN FIRM
Sandstrom Design,
Portland, Oregon
CREATIVE DIRECTOR
Steve Sandstrom
DESIGNERS
Steve Sandstrom,
Janée Warren, Amy
Devletian
COPY WRITER Steve
Sandoz
CLIENT Tazo Teas,
Portland, Oregon
CLIENT CONTACT
Steve Smith, President

*Sandstrom actually
wanted the packaging
to be more elaborate,
with more handwriting
and a more personal
look. But it came
down to designing
eight packages in a
few weeks to ready
the product launch.*

*Tazo intended to
print the hot tea box
on uncoated stock,
but standard stocks
and sizes had be to
used.*

*A new die was
required for the tab
at the bottom, a
detail that could be
accommodated.*

*The loading of bags
into boxes at the
manufacturer's end
restricted the idea of
changing how the
box opens.*

*The only hint of
color, in an otherwise
black-and-beige
scheme, is found in
the seals and bags.*

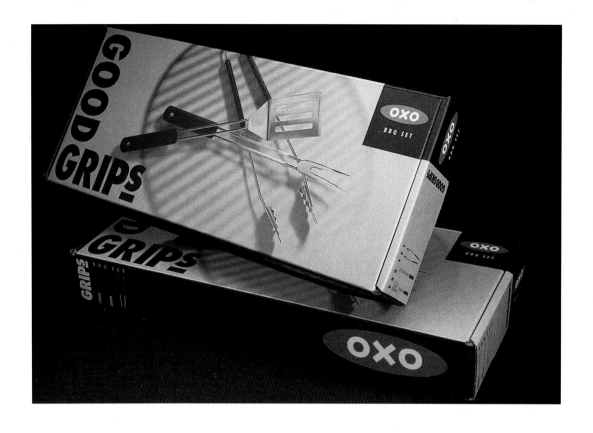

DESIGN FIRM Hornall Anderson
 Design Works
ART DIRECTOR Jack Anderson
DESIGNER Jack Anderson, Heidi Favour,
 John Anicker
CLIENT OXO International
PRODUCT OXO Good Grips Barbecue tools

A natural Kraft box helped the product stand out among its competitors, which use a more slick and glossed box surface. Although rough in appearance, the closed box treatment on Kraft paper emphasizes a more upscale quality in simplicity, as well as a higher grade of product quality.

DESIGN FIRM Mires Design
ART DIRECTOR José A. Serrano
DESIGNER José A. Serrano, Miguel Perez
ILLUSTRATOR Tracy Sabin
CLIENT Found Stuff Paper Works
PRODUCT Notepads on 100 percent recycled paper

All of the materials used in both this product and package are recycled and natural. The cotton was organically grown, and the material left over from the cotton was recycled into paper pulp that was later used to make the paper for the sketch books. The labels were printed with soy ink.

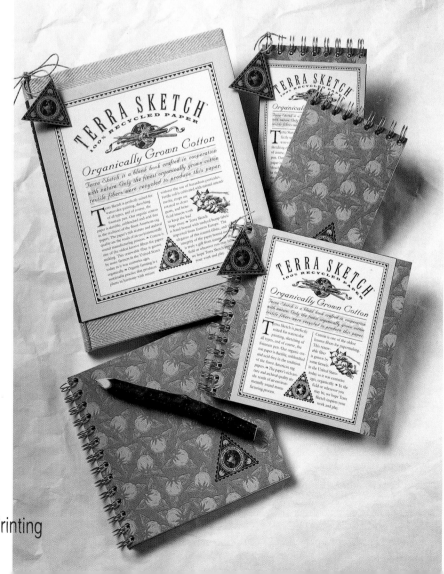

LAIRD LIBRARY
Glasgow College of Building & Printing
60 North Hanover Street

DESIGN FIRM
Hornall Anderson
Design Works Inc.
ART DIRECTOR
Jack Anderson
DESIGNER
Jack Anderson,
Lisa Cerveny,
Suzanne Haddon
ILLUSTRATOR
Mits Katayama
CLIENT/STORE
Juice Club
BAG MANUFACTURER
Zenith Paper
PAPER/PRINTING
Kraft; flexo

The pastry and take-out bags were designed in Macromedia FreeHand. The main challenge faced during printing was keeping the gradation from filling in and keeping the colors pure while using only four colors that graduated from deep red to green.

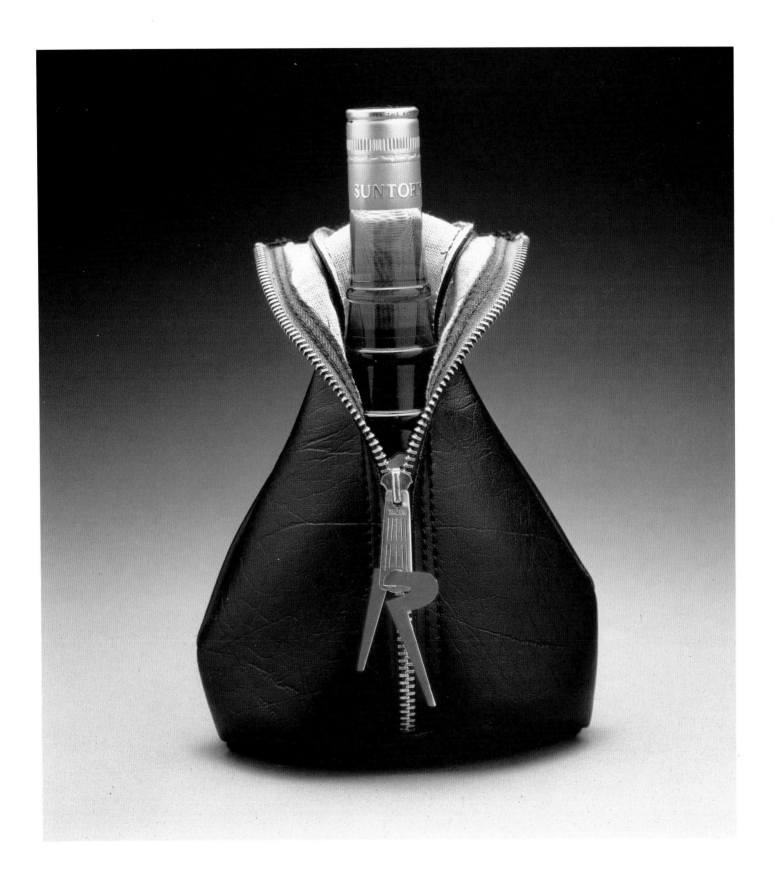

DESIGN FIRM Mike Salisbury Communications

ART DIRECTOR Mike Salisbury

DESIGNER Mike Salisbury

CLIENT Suntory

OBJECTIVE

To produce packaging for a "late night" liqueur

INNOVATION

From the rich black leather texture to the bright red zipper pull, this packaging says "exotic" tinged with the "dramatic" when the rest of the market just says "moderate."

Product

DESIGN FIRM
Hornall Anderson Design Works
ART DIRECTOR Jack Anderson
DESIGNERS
Jack Anderson, Julie Lock, Julie Keenan
ILLUSTRATOR John Fretz
PROJECT Starbucks Mazagran four-pack
and bottle packaging
CLIENT Starbucks Coffee Company
PURPOSE OR OCCASION
Product packaging
SOFTWARE
Macromedia FreeHand, Adobe Photoshop
HARDWARE Macintosh

The name Mazagran originated in
1830 in the French Foreign Legion fort
city in Algeria. Weary soldiers returning
from battle would mix sparkling water
with coffee. Illustrations of the arid map,
coastline, fort, and soldiers were
collected from assorted history books.
After extensive research, a customized
bottle shape was chosen that would
enhance the desirability of the product
with focus given to the user-friendly
shape.

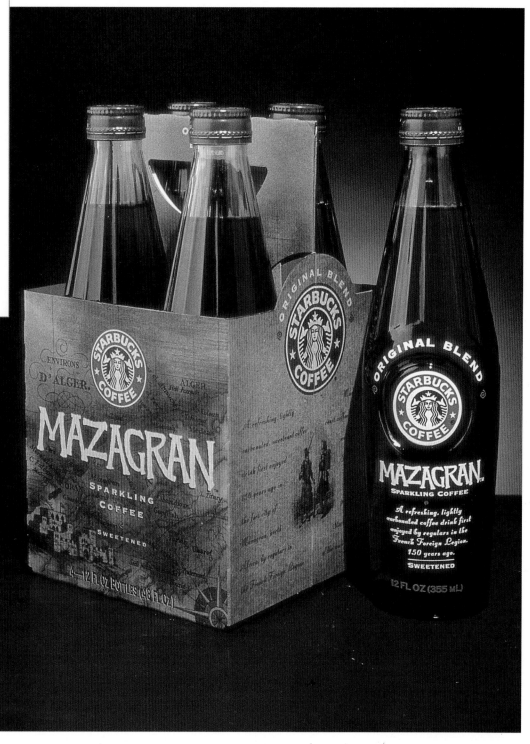

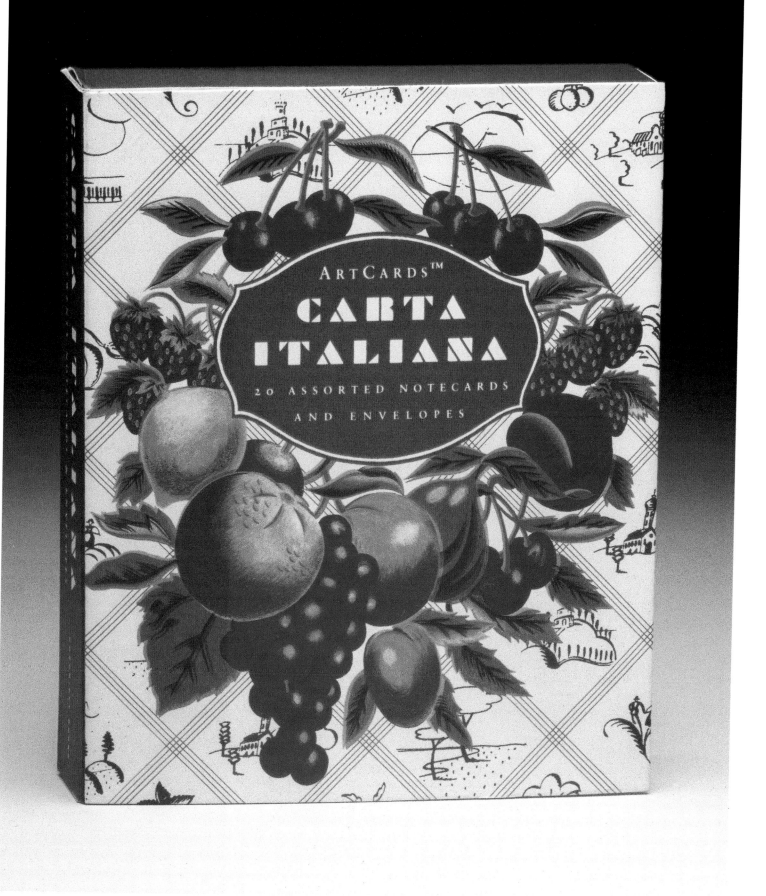

DESIGN FIRM Louise Fili Ltd.

ART DIRECTOR/DESIGNER Louise Fili

ILLUSTRATOR Melanie Parks

CLIENT Chronicle Books

PRODUCT Greeting cards

TECHNIQUE Offset

This box of greeting cards is based on the designer's collection of Italian orange wrappers. The illustration was done in gouache, and all type was done on the computer.

Last night The Fly *was on TV, and the Misfits wrote a song called 'Return of the Fly,' which was about the sequel to that movie. That's the great thing: [the band] is very movie-oriented [with songs like] 'Astro Zombies' and 'She.' So it was great watching that movie and realizing this is exactly what the band is about. The words meet the absurdity of the way they dressed up on stage and their record covers, etc. I wanted to make sure I included not only the original artwork for all the records, but we also wanted to make them colorful. So we used duotones, like the blues and reds, and made sure we showed the old track listings underneath the song tracks in the front of the book, and the movie poster that's in the front and the one that's in the back. One of my favorite parts is the black cases—I just couldn't put* Static Age *on the other three discs. I wanted that separate, to have its own special packaging, because as far as I'm concerned it's one of the top five punk albums of all time. We wanted this to be special, not something that you just put away."*

—TOM BEJGROWICZ, CAROLINE RECORDS

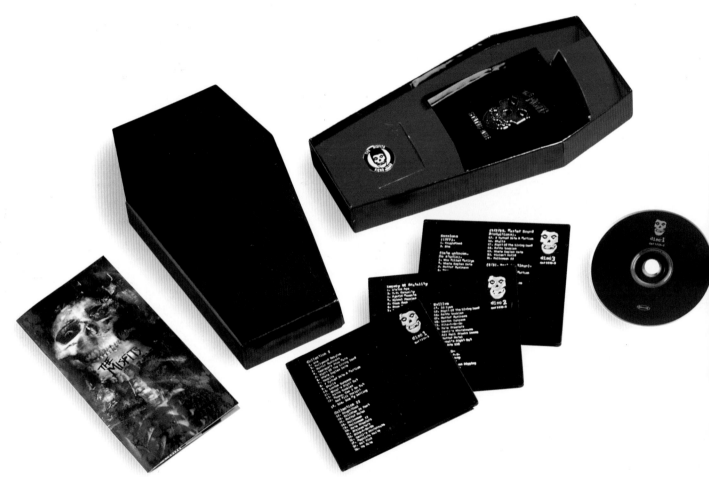

The Misfits

The Misfits (Caroline Records)

DESIGNER Roger Gorman, Reiner Design, NYC

ART DIRECTORS Tom Bejgrowicz and Roger Gorman

ILLUSTRATOR Dave McKean

LINER NOTES Eerie Von

BOX SET PRODUCER Tom Bejgrowicz

PACKAGING AGI

ENAMEL BADGE T. J. Productions

Considering the brevity of their existence, the Misfits certainly made a huge impact on both the punk rock and heavy metal music scenes. They themselves were like some strange mutant concoction of vintage '50s sci-fi flicks and the Ramones, blending an impeccable pop sensibility with edgy punk energy and over-the-top ghoulish imagery. There are a lot of bands who might be worthy of this coffin-as-boxed set idea, but the Misfits deserved a deluxe boxed-set, as many of their records are quite rare.

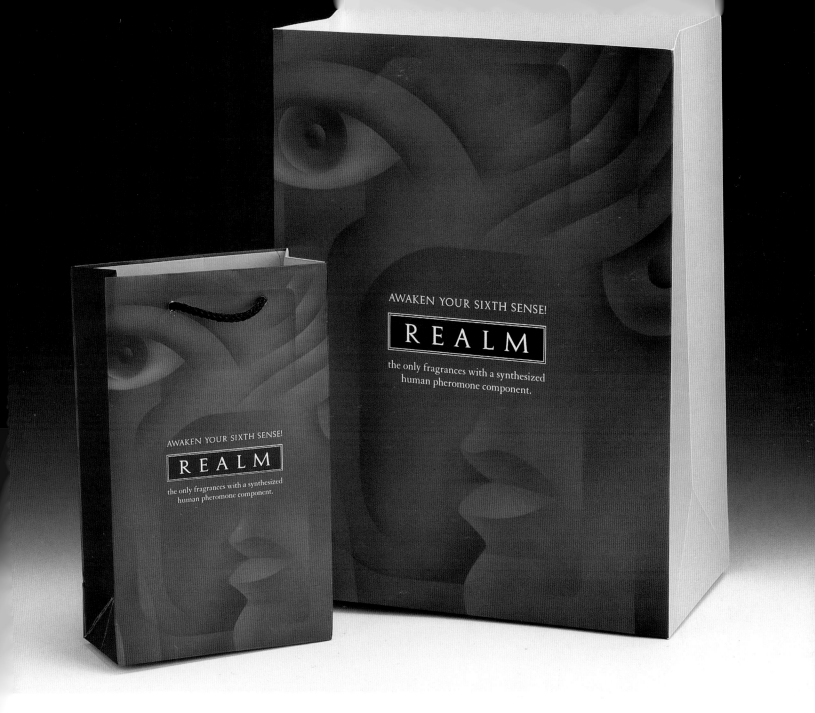

DESIGN FIRM 1185 Design
ART DIRECTOR Andy Harding
DESIGNER Andy Harding
CLIENT/STORE Realm Fragrance
BAG MANUFACTURER North American Packaging Corp.
PAPER/PRINTING Bleached white coated 25 lb.

*The bags advertise a fragrance that employs a human
pheromone. The illustration subtly conveys this
scientific component.*

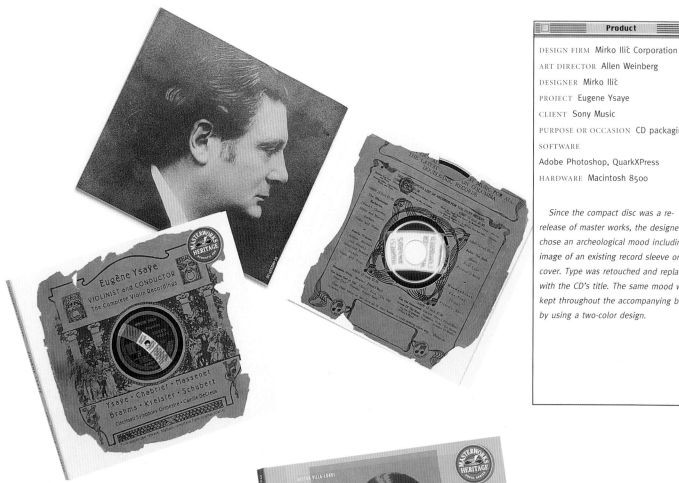

Product

DESIGN FIRM Mirko Ilić Corporation

ART DIRECTOR Allen Weinberg

DESIGNER Mirko Ilić

PROJECT Eugene Ysaye

CLIENT Sony Music

PURPOSE OR OCCASION CD packaging

SOFTWARE

Adobe Photoshop, QuarkXPress

HARDWARE Macintosh 8500

Since the compact disc was a re-release of master works, the designer chose an archeological mood including an image of an existing record sleeve on CD cover. Type was retouched and replaced with the CD's title. The same mood was kept throughout the accompanying book by using a two-color design.

Product

DESIGN FIRM Mirko Ilić Corporation

ART DIRECTOR Allen Weinberg

DESIGNER Mirko Ilić

PROJECT Bidu Sayao

CLIENT Sony Music

PURPOSE OR OCCASION CD packaging

SOFTWARE

Adobe Photoshop, QuarkXPress

HARDWARE Macintosh 8500

In order to make the front and back covers of a re-released masterworks catalog attractive, graphical elements were created in Photoshop.

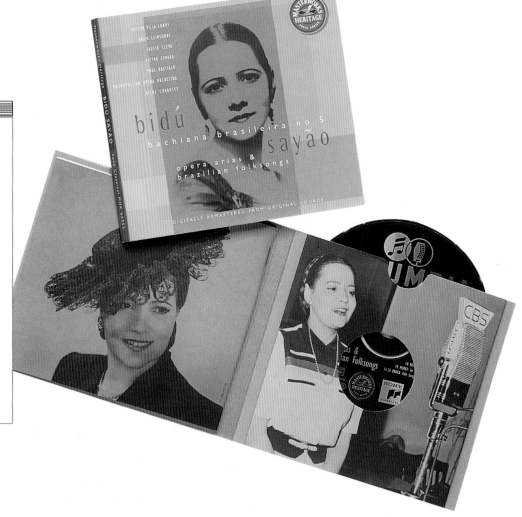

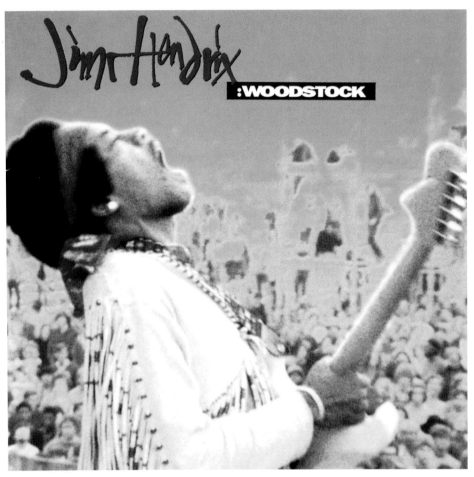

Jimi Hendrix Woodstock (MCA Records)

DESIGNERS

John O'Brien and Jeff Smith, Cimarron/Bacon/O'Brien

DESIGN CONSULTANT

Vartan

PHOTOGRAPHER

Allan Koss

ELECTRONIC IMAGER

Adrian Boot/Exhibit-A

At Woodstock, Jimi Hendrix fully evinced the spirit of his electric church, rapping with the crowd and playing his festival-capping set as the sun drove away the torrential rain and streaked the sky with dappled purple psychedelic light. This cover does the same, as the distorted audience and rolling grassy hills behind Hendrix blur into an acid-tinted frame for the exploratory, volume-fueled blues-rock within.

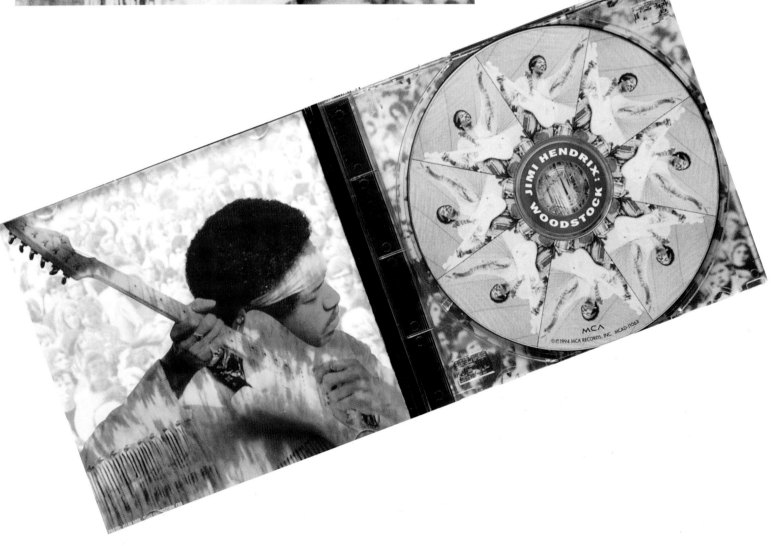

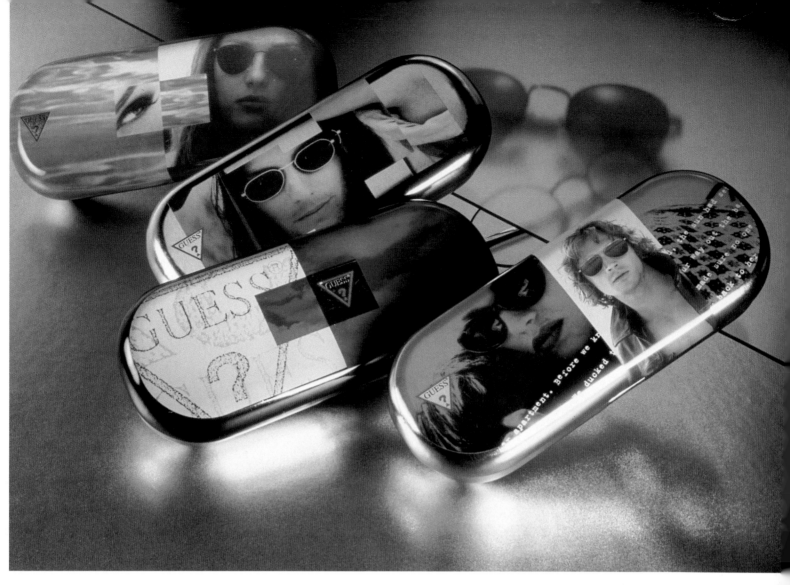

DESIGN FIRM Parham Santana Inc.

ART DIRECTOR Maruchi Santana

DESIGNER Millie Hsi

CLIENT Viva International Group

PRODUCT Sunglasses case

TECHNIQUE Four-color process over tin

A set of four collectible tins serve as a point-of-purchase display and also help to distinguish the client in a mature and crowded eyewear market.

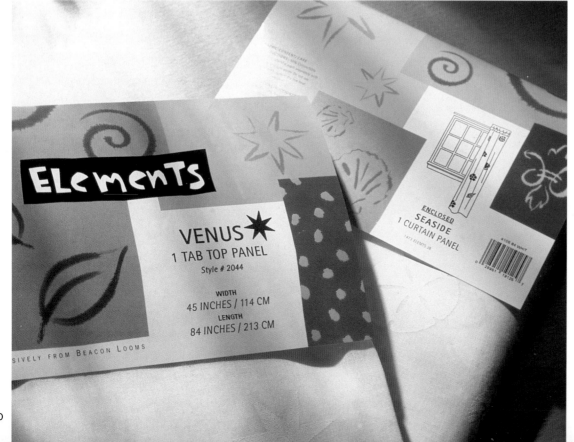

DESIGN FIRM

Parham Santana Inc.

ART DIRECTOR

Maruchi Santana

DESIGNER/ILLUSTRATOR

Lori Reinig

CLIENT

Beacon Looms

PRODUCT

Tab top curtains

TECHNIQUE

Offset

"Elements" was a name and packaging concept conceived by Parham Santana Inc. for a graphic-driven curtain program. This packaging stands out in a marketplace where product photography is the norm.

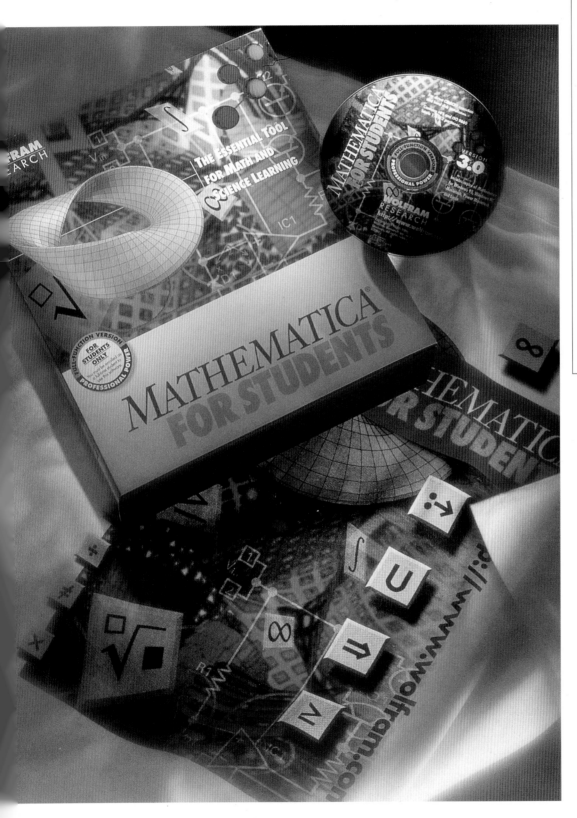

Product

DESIGN FIRM

Wolfram Research Creative Services

ART DIRECTOR/ILLUSTRATOR

John Bonadies

DESIGNERS John Bonadies, Jody Jasinski

PROJECT Mathematica 3.0 Student

Version packaging

CLIENT Wolfram Research, Inc.

PURPOSE OR OCCASION

New product development

SOFTWARE Mathematica, Adobe

Illustrator, Adobe Photoshop, QuarkXPress

HARDWARE Power Computing Power

Wave 640/120

The design is a brighter and more animated subset of the professional package, utilizing multi-layered dimensional graphics to illustrate and communicate the product features. This sets a visual analogy while maintaining a strong corporate relationship to established identity standards.

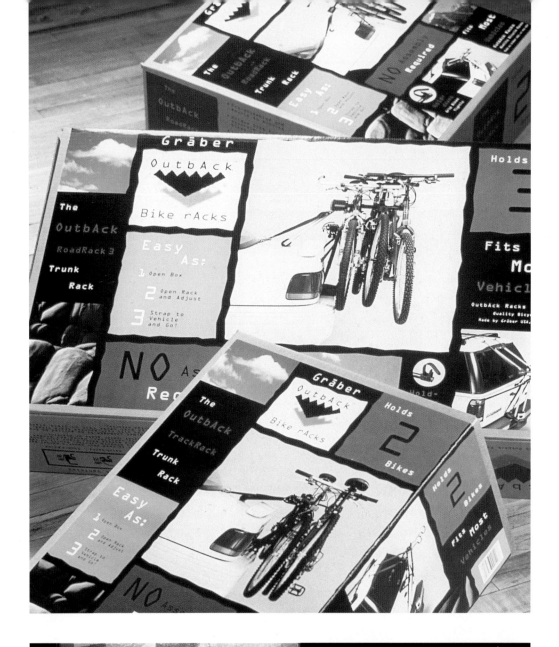

DESIGN FIRM
Planet Design Company
ART DIRECTOR
Dana Lytle, Kevin Wade
DESIGNER
Dana Lytle, Raelene Mercer
CLIENT
Gráber USA
PRODUCT
Outback bike racks
TECHNIQUE
Lithowrap, offset; box, flexography

Planet Design Company's challenge was creating packaging that evoked all the outdoor imagery associated with biking while fitting into the mass merchandise environment. The design was created with QuarkXPress.

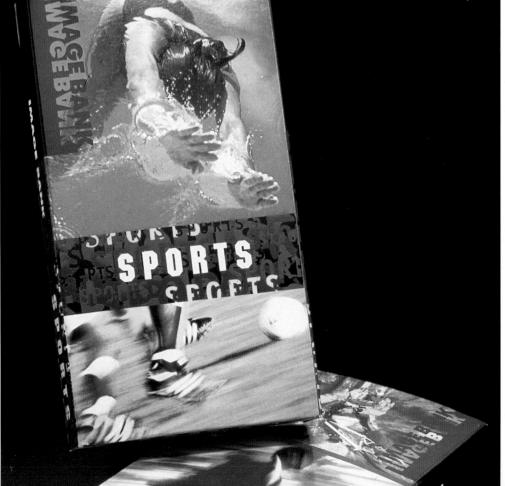

DESIGN FIRM
Sibley-Peteet Design
ART DIRECTOR
Donna Aldridge
DESIGNER
Donna Aldridge, Diane Fannon
ILLUSTRATOR
Donna Aldridge
CLIENT
The Image Bank
PRODUCT
Video
TECHNIQUE
Offset

The client wanted to promote its sports photography, illustration, and film, with a very interactive piece that left the recipient with a fun premium. The package unfolds to reveal a videocassette of sports footage and a pocket folder containing twelve "trading" cards with different sports imagery. The design was created with QuarkXPress and Adobe Illustrator.

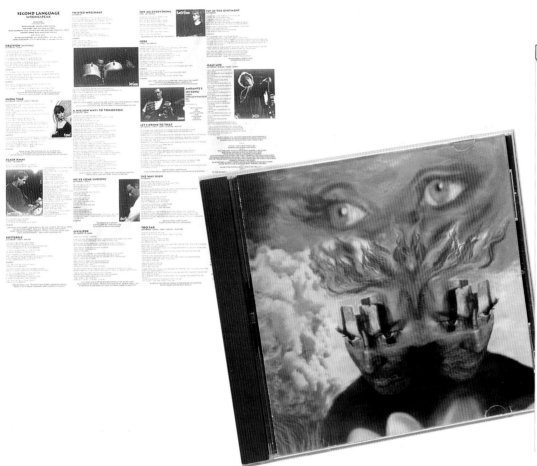

Promotion

DESIGN FIRM Toni Zeto
ALL DESIGN Toni Zeto
PROJECT Wrong Speak
CLIENT Second Language
PURPOSE OR OCCASION
Compact-disc insert
SOFTWARE Adobe Photoshop
HARDWARE Macintosh

The main idea for this CD-case cover-art insert was to render a 90s version of 60s psychedelic stream of consciousness. First, a loose acrylic sketch of a forehead dangling as a mobile over the earth surrounded by flames was rendered. The images were then projected onto each band member and photographed separately. All images were scanned into Photoshop, where airbrush and various paint tools were used to combine all the images and finish the cover illustration.

Promotion

DESIGN FIRM Tracy Sabin Graphic Design
ART DIRECTOR Linda Weidenbaum
ILLUSTRATOR Tracy Sabin
PROJECT Charlotte Russe shopping bag
CLIENT Charlotte Russe
PURPOSE OR OCCASION
Holiday promotion
SOFTWARE Adobe Illustrator
HARDWARE Macintosh 9500

This promotion/shopping bag was designed for holiday shoppers at Charlotte Russe, a women's-wear retailer.

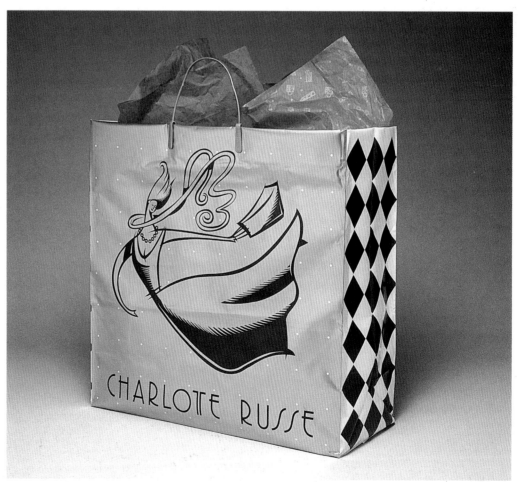

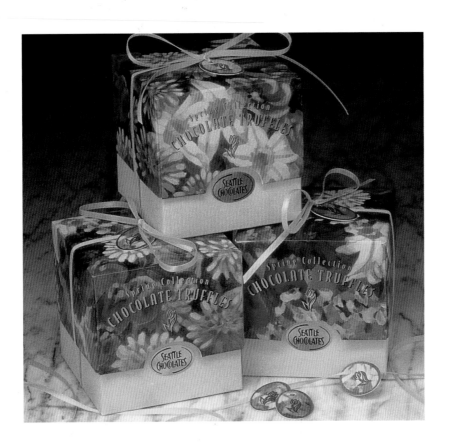

Product

DESIGN FIRM
Hornall Anderson Design Works
ART DIRECTOR Jack Anderson
DESIGNERS Jack Anderson, Jana Nishi
ILLUSTRATOR Mary Iverson
PROJECT Seattle Chocolates seasonal
spring packaging
CLIENT Seattle Chocolate Company
PURPOSE OR OCCASION
Product packaging
SOFTWARE Macromedia FreeHand
HARDWARE Macintosh

This box for assorted chocolates was designed as a seasonal promotional gift box as well as packaging for the client's product. Multi-colored, floral illustrations reflect the theme of spring, as does the box's bright-yellow bottom.

Product

DESIGN FIRM Marcolina Design, Inc.
ALL DESIGN Dermot MacCormack
PROJECT Fontek Express packaging
CLIENT Letraset USA
PURPOSE OR OCCASION Packaging for
new product
SOFTWARE Adobe Photoshop, Spectral
Collage, Adobe PageMaker, Adobe
Illustrator
HARDWARE Power Macintosh 9500

Letraset introduced a new type service to its vendors whereby customers can custom pick fonts and have them put on disks or a CD-ROM. This package design contains these disks as well as a type specifier for further use. PageMaker was used for its compatibility with the hexachrome printing that was used on this piece.

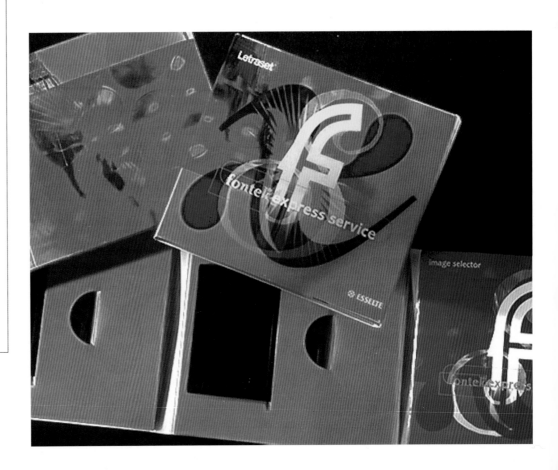

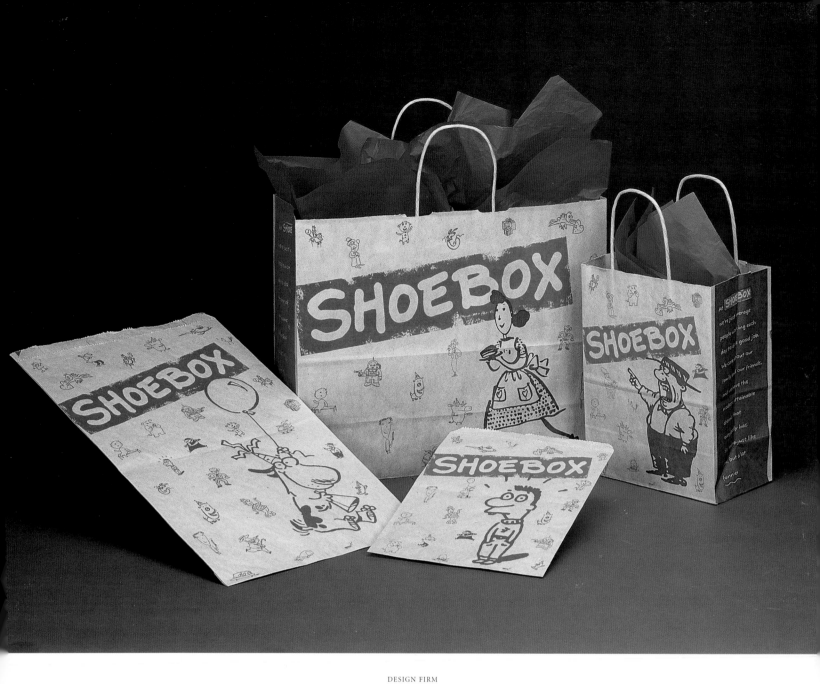

DESIGN FIRM
Hallmark Cards Inc.
ART DIRECTOR
Mark Lineback
DESIGNER
Mark Lineback
ILLUSTRATOR
Shoebox Artists
CLIENT/STORE
Shoebox Greetings
BAG MANUFACTURER
Bonita Pioneer
PAPER/PRINTING
Kraft; flexo

*Recycled kraft stock, dotted
with featured characters,
reflects the down-to-earth
Shoebox greeting-card line.
Editorial content, brought into
the gussets of the bag, is a
huge part of the playful
Shoebox personality.*

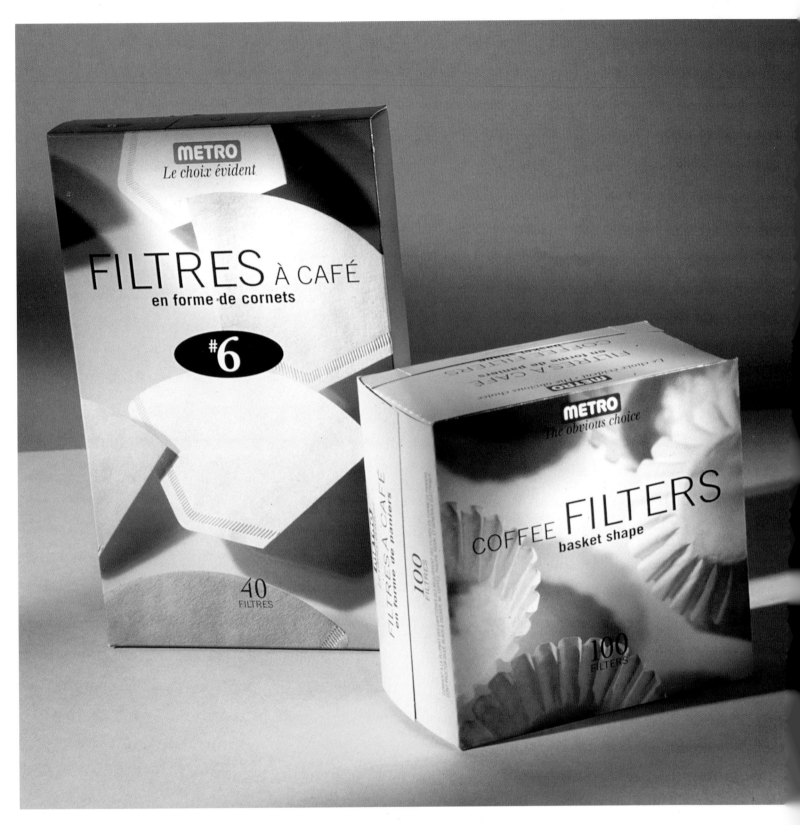

DESIGN FIRM Goodhue & Associés

ART DIRECTOR Suzanne Côté

DESIGNER Suzanne Côté, Andre Saint-Loup

ILLUSTRATOR Louis Prud'homme

CLIENT Épiciers unis Métro-Richelieu

PRODUCT Coffee filters

Goodhue & Associés used an original and interesting approach to photographing the product. Pastel colors ensure that it stands apart from the competition.

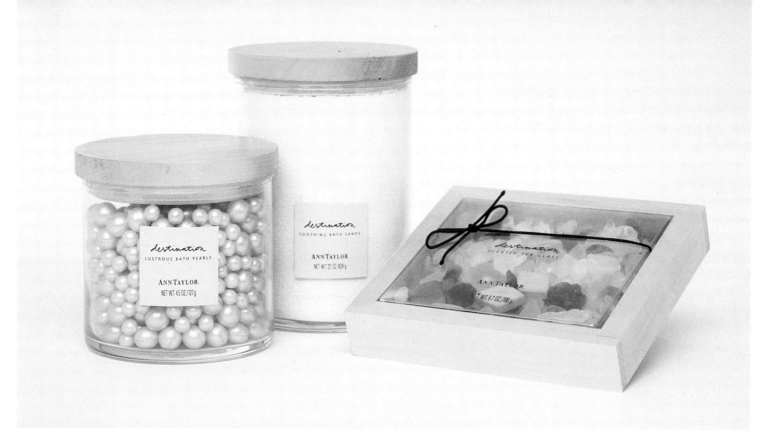

DESIGN FIRM Desgrippes Gobé & Associates
CREATIVE DIRECTOR Peter Levine, Kenneth Hirst
DESIGN DIRECTOR Frances Ullenberg
DESIGNER Christopher Freas
CLIENT Ann Taylor Inc.
PRODUCT Ann Taylor Destination fragrance

This packaging reinforces the Ann Taylor brand identity by communicating a natural, honest design that is consistent with the store's total retail identity. The fragrance packaging's materials are made from recycled and recyclable materials and have soft, nature-based shapes.

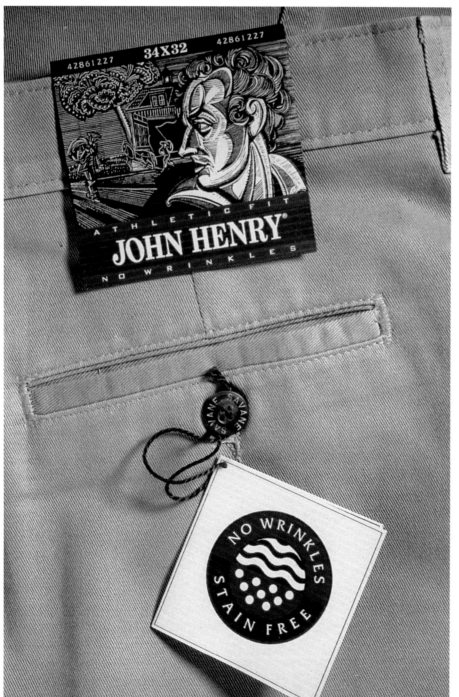

DESIGN FIRM Sibley-Peteet Design
ART DIRECTOR Bryan Jesse, Rex Peteet
DESIGNER Rex Peteet, Derek Welch
ILLUSTRATOR Stephen Alcorn
CLIENT Farah
PRODUCT Men's clothing
TECHNIQUE Offset, weaving

Sibley-Peteet Design created a new identity for a younger market. The client wanted a solid, bold, simple feel. Woodcuts were scanned into Adobe Illustrator.

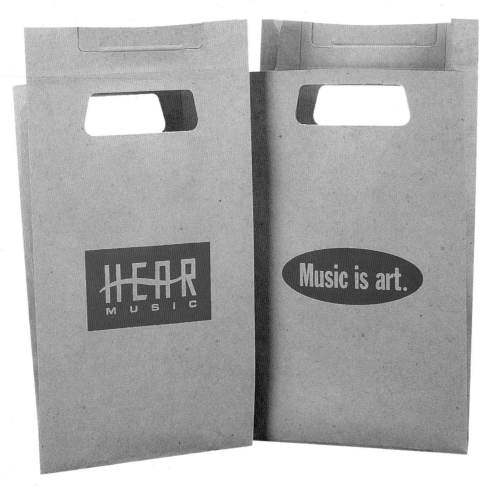

DESIGN FIRM
Howard Decorative
Packaging
ART DIRECTOR
Jen Gadbois,
Lisa Laarman
DESIGNER
Jen Gadbois,
Lisa Laarman
ILLUSTRATOR
Lisa Laarman
CLIENT/STORE
Hear Music
BAG MANUFACTURER
Handelok Bag Co.
PAPER/PRINTING
Recycled natural
kraft; flexo

DESIGN FIRM
Sony Design Center
ART DIRECTOR
Yuka Takeda
DESIGNER
Yuka Takeda
CLIENT/STORE
Sony Style
DISTRIBUTOR
S. Posner Sons Inc.

The Sony Style bags reflect the clean, clear, contemporary look of the new Sony stores, an updated look from the previous Sony Plaza bags.

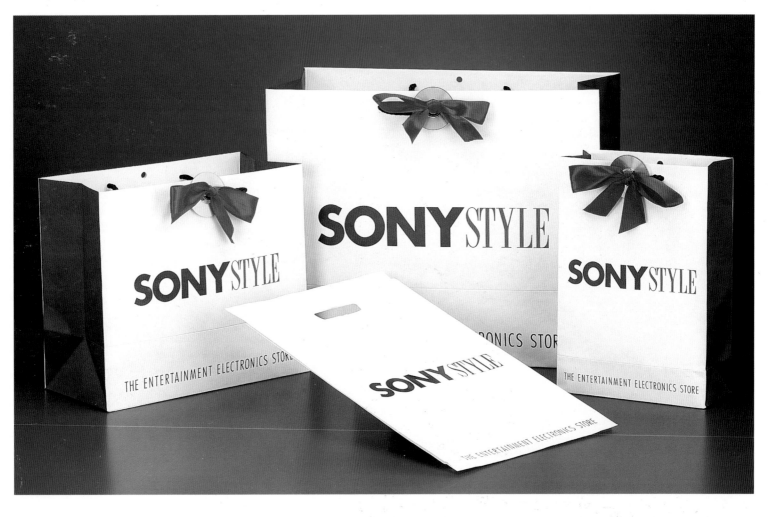

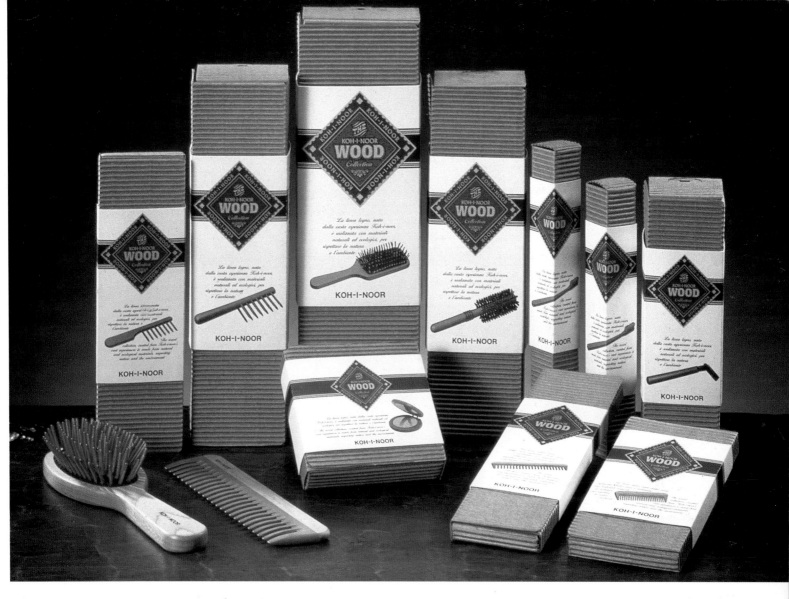

DESIGN FIRM Robilant & Associati
ART DIRECTOR Maurizio di Robilant
DESIGNER Lucia Sommaruga
CLIENT Koh-I-Noor Italy
PRODUCT Wood collection

The project's aim was to create natural, environmentally-friendly packaging for a line of combs and brushes made of natural materials (wood, hair). Instead of using acetate, the designers used drawings to represent the product contained in the box. The whole package needs only one glue point.

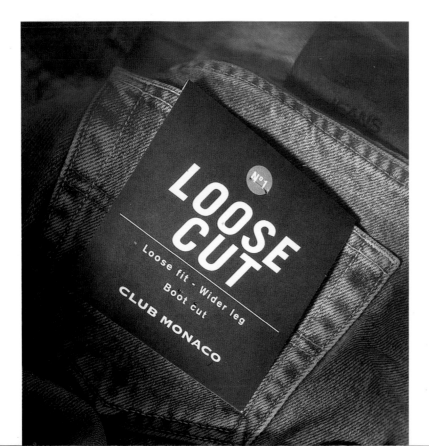

DESIGN FIRM Teikna
ART DIRECTOR/DESIGNER Claudia Neri
CLIENT Club Monaco
PRODUCT Jeans Tag
TECHNIQUE Offset

For their Fall '96 jeans, Club Monaco needed a design for their pant tags which would fit with the retailer's simple, modern image, and appeal to men. Artwork was done in QuarkXPress.

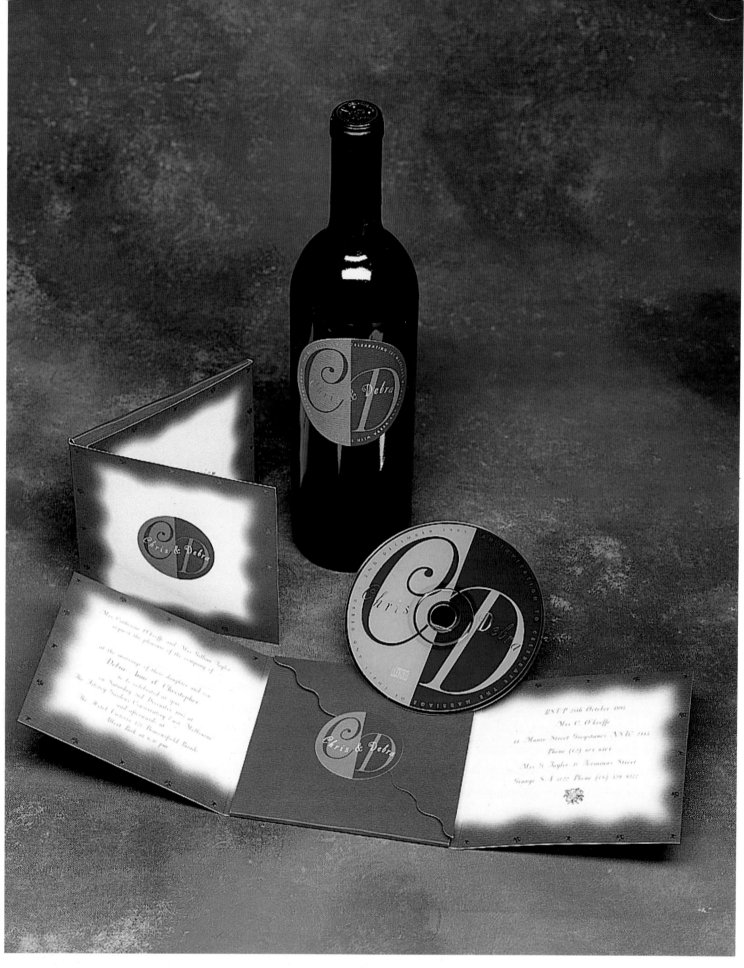

DESIGN FIRM Watts Graphic Design

ART DIRECTOR/DESIGNER Helen and Peter Watts

CLIENT Chris and Debra

PRODUCT Wedding invitation

TECHNIQUE Offset

Chris and Debra actually speak on this CD to invite their guests. It was unique and successful.

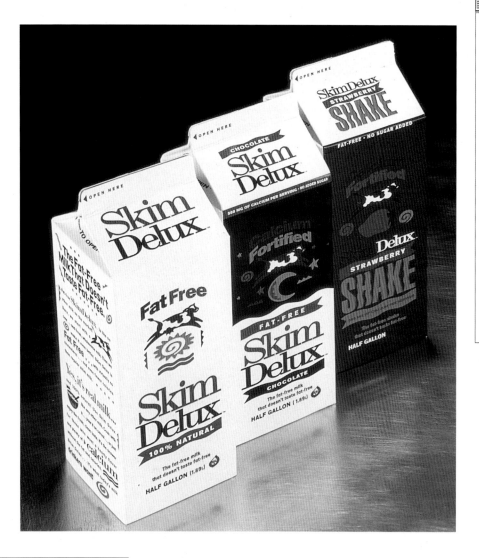

Product

DESIGN FIRM Greteman Group

ART DIRECTORS/DESIGNERS

Sonia Greteman, James Strange

ILLUSTRATORS James Strange, Sonia

Greteman, Craig Tomsom

PROJECT Skim Delux packaging

CLIENT Skim Delux

SOFTWARE Macromedia FreeHand

HARDWARE Macintosh Power PC

A simple illustration and type treatment was necessary for the surrounding graphics with all art created in FreeHand. The jumping cow remained consistent and was positioned over a representation of whatever the particular flavor of the product was.

Product

DESIGN FIRM Greteman Group

ART DIRECTOR/ILLUSTRATOR

Sonia Greteman

DESIGNERS

Sonia Greteman, James Strange

PROJECT Flower and herb packaging

CLIENT Hayes Forest

SOFTWARE

Macromedia FreeHand, Adobe Photoshop

HARDWARE Macintosh Power PC

All graphics were created in FreeHand with the exception of the major illustration. The illustration was hand-tinted and then scanned in to Adobe Photoshop. Earth tones were used with a smattering of bright color to highlight the product's name.

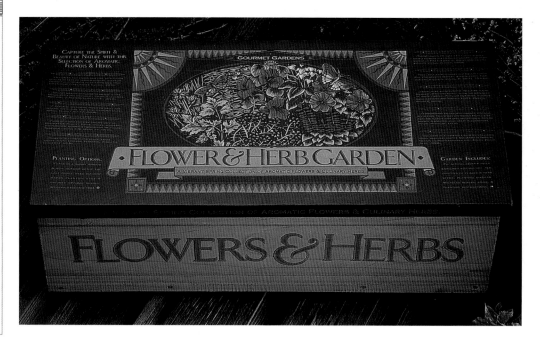

DESIGN FIRM
Bijan Fragrances
ART DIRECTOR
Daniel Pakzad
CLIENT/STORE
Bijan Fragrances
BAG MANUFACTURER
PSPCO/12:34 Ltd./Korus

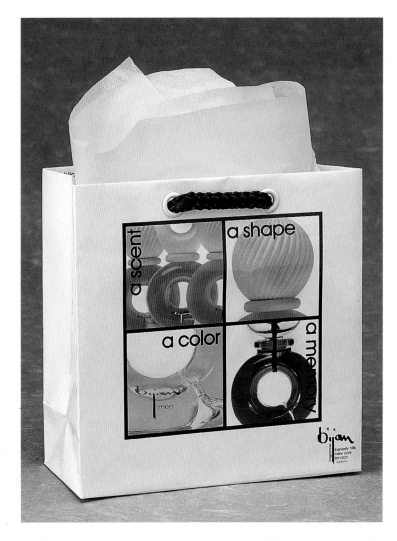

DESIGN FIRM
Matins Bleus, Paris
CLIENT/STORE
Cosmoline, Paris
BAG MANUFACTURER
PSPCO/12:34 Ltd./Korus

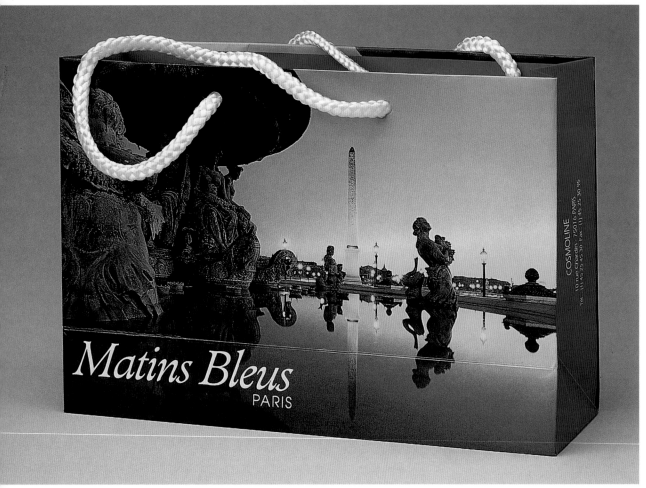

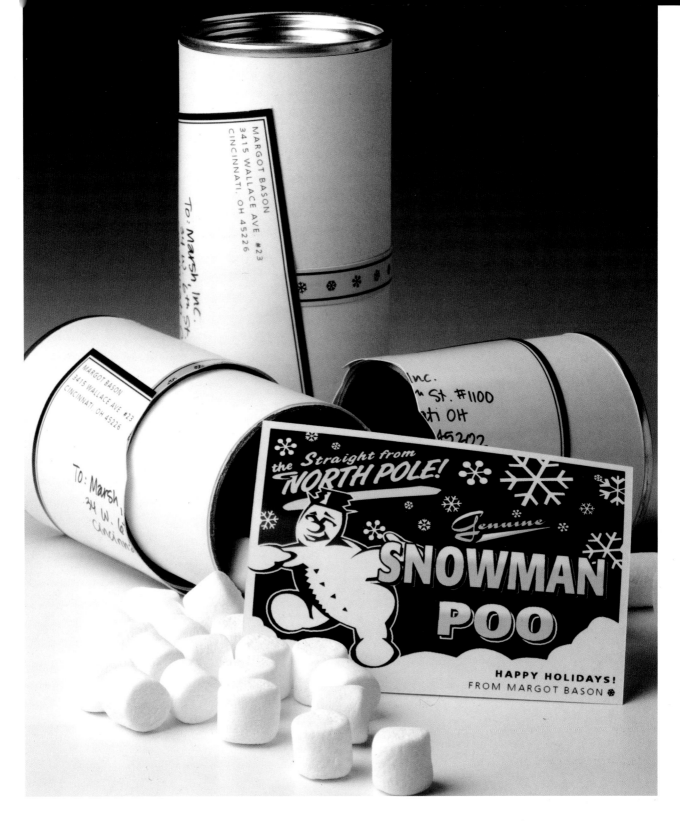

DESIGN FIRM Marsh, Inc.

ART DIRECTOR/DESIGNER Margot Bason

PURPOSE OR OCCASION Holiday greeting

NUMBER OF COLORS Two

The project was a unique approach to the average holiday card. The package is a mailing tube filled with mini-marshmallows. A self-adhesive snowflake strip seals the container for delivery.

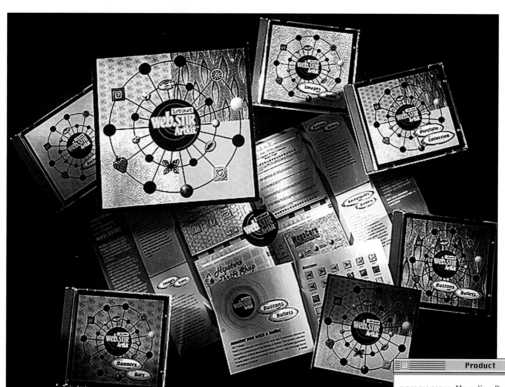

Product

DESIGN FIRM Marcolina Design, Inc.

ART DIRECTOR Dan Marcolina

DESIGNER/ILLUSTRATOR
Rebekah Higgins

PROJECT Packaging design and
illustration/web.stir art kit

CLIENT Letraset USA

PURPOSE OR OCCASION
Create presence for product

SOFTWARE Adobe Photoshop, Adobe
Illustrator, QuarkXPress

HARDWARE Power Macintosh 7500/100

The client needed illustrations and package design that would be coordinated, eye catching, sum up the nature of the product, and incorporate elements from the collection. The hard-line graphics were created in Illustrator and then dropped into Photoshop where the art kit elements logo type were added. Backgrounds were created with pattern fills and then colorized.

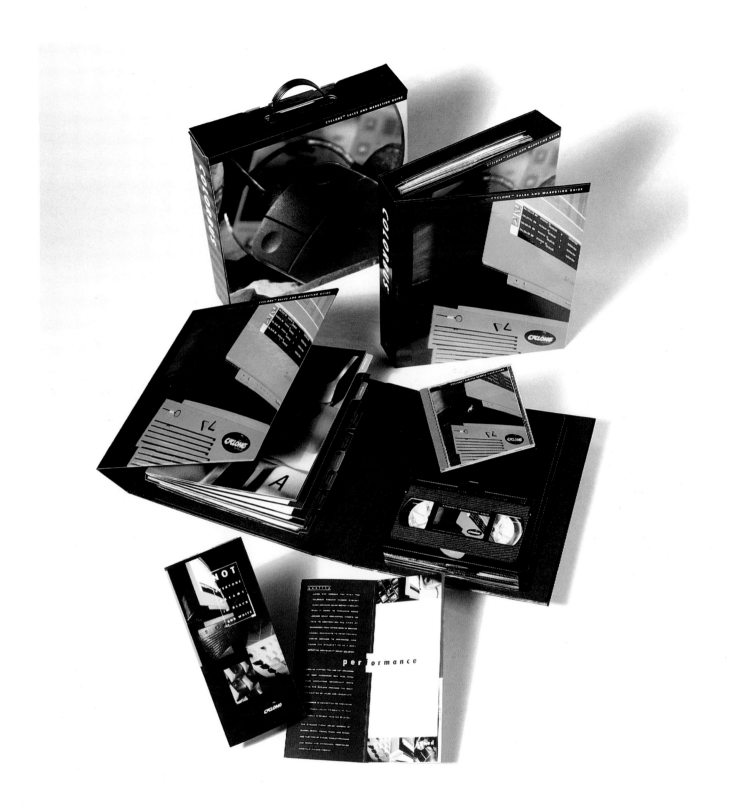

DESIGN FIRM David Riley + Associates

ART DIRECTOR David Riley

DESIGNERS Dennis Thorp, David Riley

PHOTOGRAPHER Lonnie Duka

CLIENT Colorbus

PURPOSE OR OCCASION Product sales package

The innovative Colorbus Cyclone Imaging System maximizes the use of color copiers by turning them into color printers and scanners. The brochures illustrate the power of communication in color through a combination of saturated photography, brilliant color, and bold design. Together with the other sales tools, they help position Colorbus as a pioneer in their field.

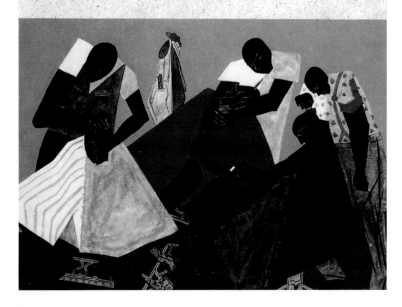

Don Byron

Music for Six Musicians (Nonesuch Records)

COVER ART BARBER SHOP (1946)

Jacob Lawrence

PHOTOGRAPHER

Anthony Barboza

Ornette Coleman

Beauty is a Rare Thing (Rhino Records)

DESIGNER

Brigid Pearson

ART DIRECTOR

Geoff Gans

Hailed as one of the first great jazz box sets when it was released in 1993, Beauty is a Rare Thing still stands as a hallmark in the since-glutted field. It remarkably compiles six discs of music along with exhaustive notes, discographies, photographs (including reproductions of all the original album covers), and personnel information into a compact six-inch square box so gorgeous to look at, you might want to own it even if you've never acquired a taste for Coleman's revolutionary free jazz.

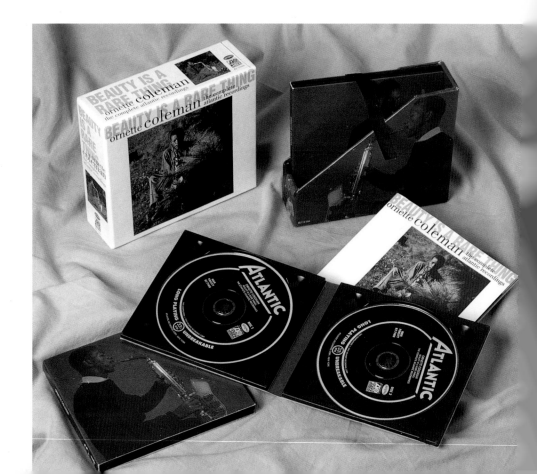

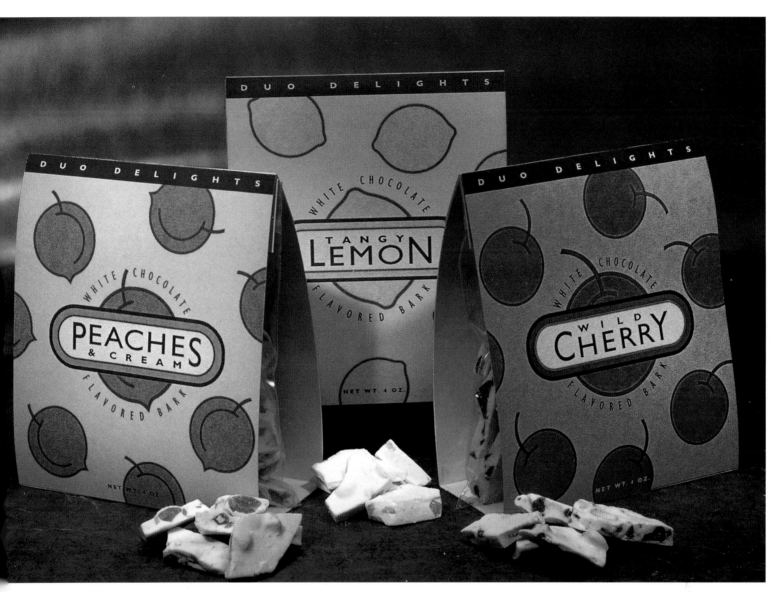

DESIGN FIRM Lambert Design
ALL DESIGN Christine Lambert
CLIENT Duo Delights
PRODUCT White chocolate bark
TECHNIQUE Offset printing

The challenge for the designer was to create a package that conveys the soft, fruity character of the product in a form that would be inexpensive to produce and easy for the client to assemble. These small, colorful pieces definitely stand out in the clutter of the specialty foods market. All art and type was created in Illustrator.

This was a real group effort, everyone had a finger in [this] one. It was the very first one where we did our own typesetting on the computer. It was kind of an experimental mix of computer graphics and still doing stuff by hand."

—JAMIE PUTNAM, DESIGNER, FANTASY

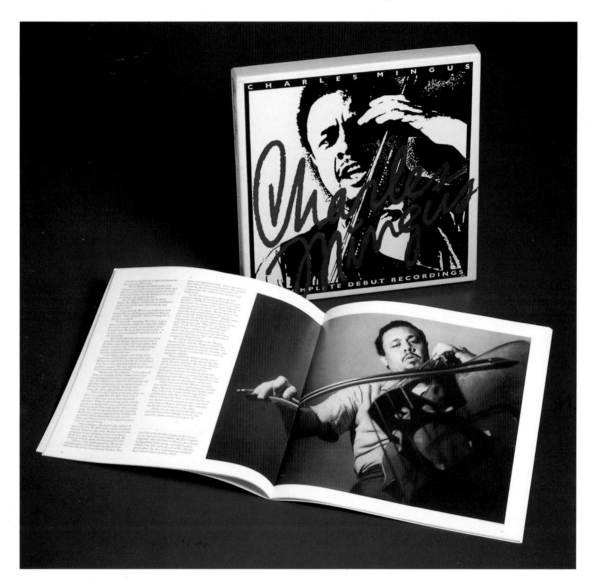

Charles Mingus

The Complete Debut Recordings (Fantasy)

DESIGNERS AND PRODUCERS

Jerri Linn, Jamie Putnam, Deborah Sibony

ART DIRECTOR

Phil Carroll

COVER ART BASED ON A PHOTOGRAPH BY

Grover Sales

Stark, masculine, and full of style, Fantasy's anthology of Charles Mingus' recordings for his own Debut label stands out with all the verve and dignity that characterized the bassist's legendary persona.

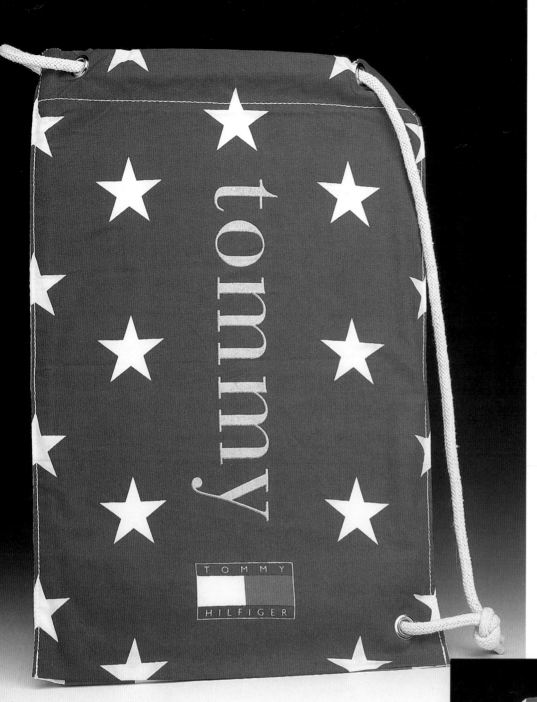

DESIGN FIRM
Estée Lauder Internal Design Group/
Tommy Hilfiger
CLIENT/STORE
Aramis Tommy Hilfiger fragrance
BAG MANUFACTURER
ModernArts production facility, Thailand
PAPER/PRINTING
Lightweight cotton; silk-screened bag;
12mm cotton cord handle with grommets.

*This illustrated the use of display bags
for product-launch promotional pieces at
retail counters.*

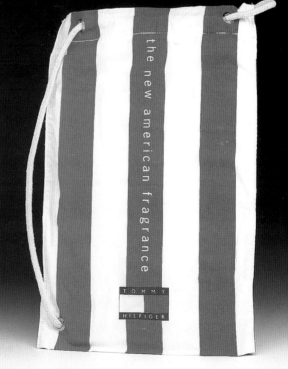

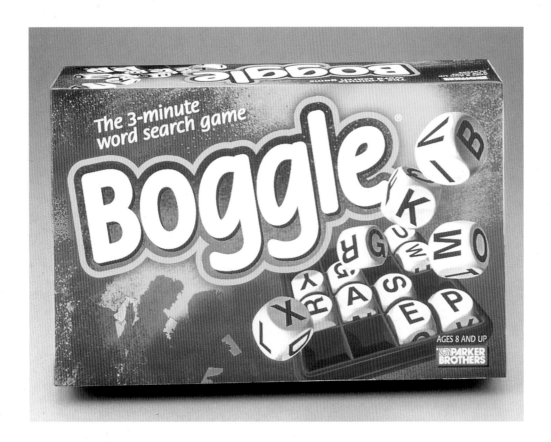

Product

DESIGN FIRM Parker Brothers
ART DIRECTOR/DESIGNER Steve Krupsky
CREATIVE DIRECTOR Nan Finkenaur
ILLUSTRATORS Fritz, Chuck Primeau,
Shannon Kriegshauser
PROJECT Boggle
PURPOSE OR OCCASION Package redesign
SOFTWARE Adobe Photoshop, Strata
StudioPro, Adobe Illustrator, QuarkXPress
HARDWARE Macintosh 9500/150

*The background textures were
composited from several digital stock
photos and combined using layer
masking in Photoshop. The original
colors of the textures, which were blue
and aqua, were shifted to red and yellow
by swapping channels. The Boggle cubes
and tray were constructed in Strata
StudioPro and final details were added
in Photoshop.*

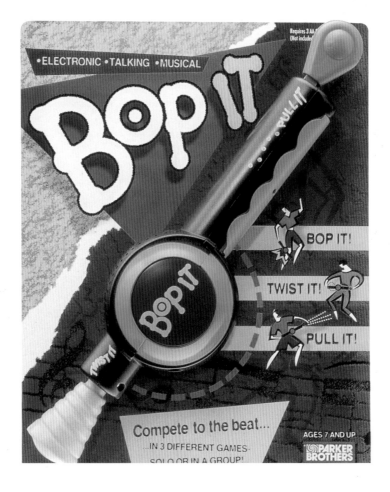

Product

DESIGN FIRM Parker Brothers
ART DIRECTOR/DESIGNER Steve Krupsky
CREATIVE DIRECTOR Nan Finkenaur
ILLUSTRATOR Lisa Henderling
PROJECT Bop It
SOFTWARE Adobe Photoshop, Adobe
Illustrator, QuarkXPress
HARDWARE Macintosh 9500/150

*The textures for the background
started out as low-resolution files in
Photoshop and increased to 300 dpi for
the final production. The logo was drawn
in Illustrator and brought into Photoshop
where the diffuse filter was used to
roughen up the black outline.*

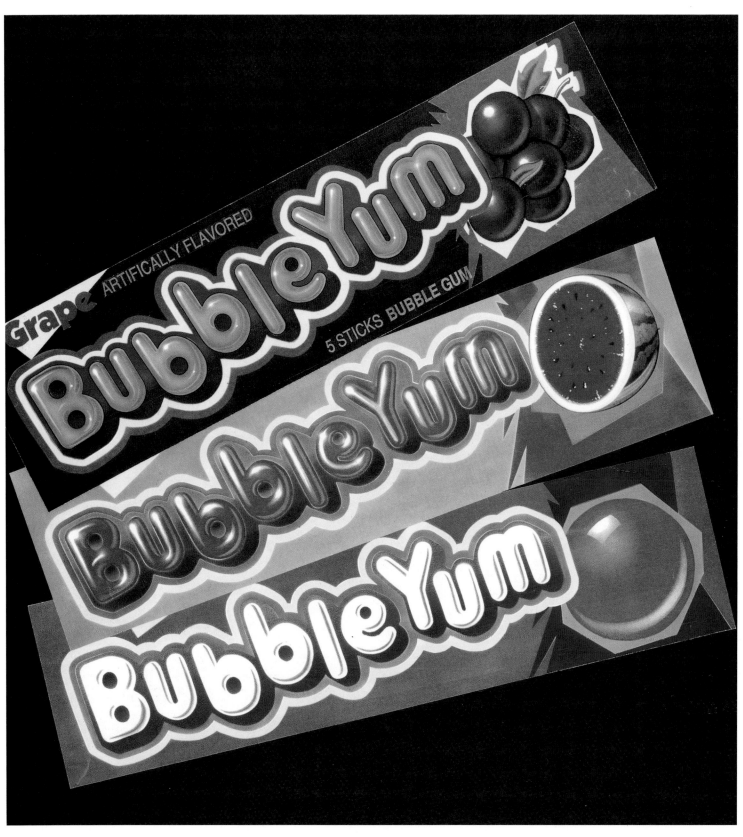

DESIGN FIRM Mike Salisbury Communications
ART DIRECTOR/DESIGNER Mike Salisbury
ILLUSTRATORS Bruce Eagle, Pat Linse
CLIENT RJR Nabisco
PRODUCT Bubble Yum Bubble Gum
TECHNIQUE Airbrush

Bubble Yum came to Mike Salisbury to try to recapture market share that they were losing to the competition. The old packaging was invisible on the racks, so the redesign used neon colors.

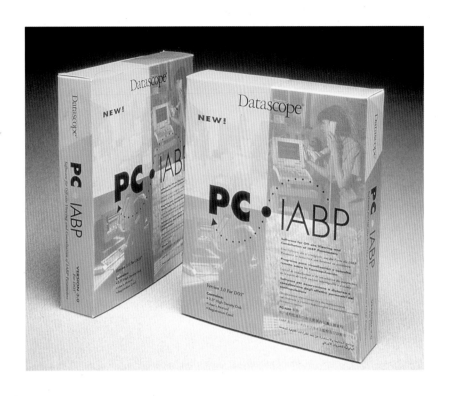

PC•IABP (Personal Computer—
Intra-Aortic Balloon Pump) is a software
product that connects sophisticated in-
room patient medical devices to doctor's
at-home computer through telemetry/
modem. Revolutionary and
unprecedented for this industry, the
packaging needed to clearly and quickly
communicate a new, complex product in
a visually exciting format.

The Fusion package clearly conveys
the product's new, revolutionary shape
and all-natural ingredients. The design
and its colors set it apart from
competitors by being futuristic and
revolutionary.

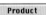
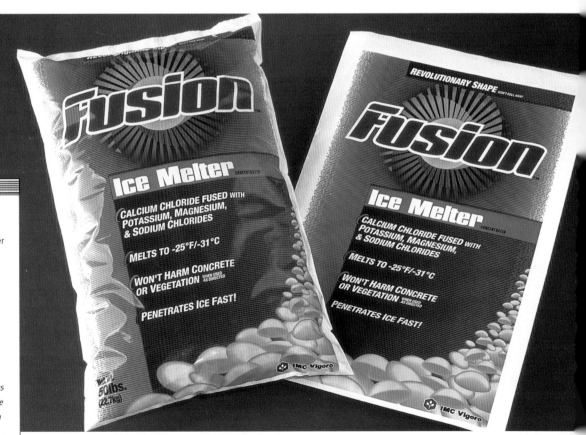

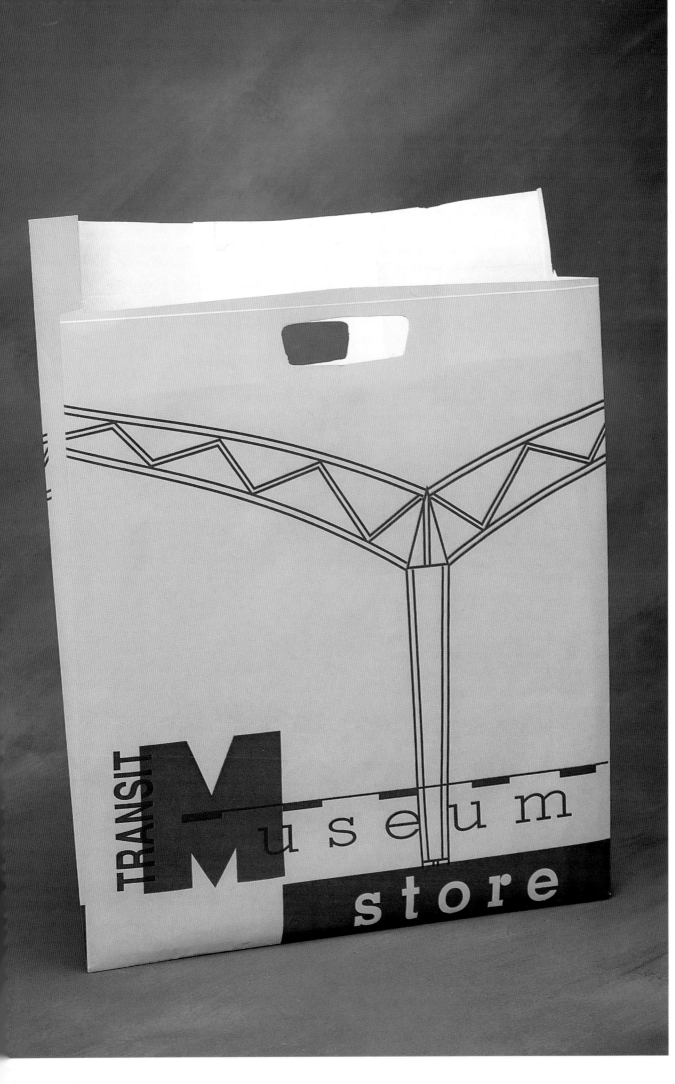

DESIGN FIRM
Commonwealth Packaging Co.
ART DIRECTOR
Sta Steinberg
DESIGNER
Gscheidle & Co.
CLIENT/STORE
Septa Transit Museum
BAG MANUFACTURER
Handelok Bag Co.
PAPER/PRINTING
White kraft; 3-color flexo

TRANSIT **M** useum

store

Compilation

Essential Blues (House of Blues Music Company)

DESIGNERS AND ART DIRECTORS

Kav DeLuxe and Kurt DeMunbrun

This first offering from the House of Blues label is a two-disc sampler of post-World War II tracks. The liner notes comprise a generous booklet full of historical notes and colorful illustrations, such as the one on this cover, the House of Blues logo. It's a beautiful design: the band of thorns and bleeding heart symbolize the music's spirituality, while the eternal flame represents its undying nature and vitality.

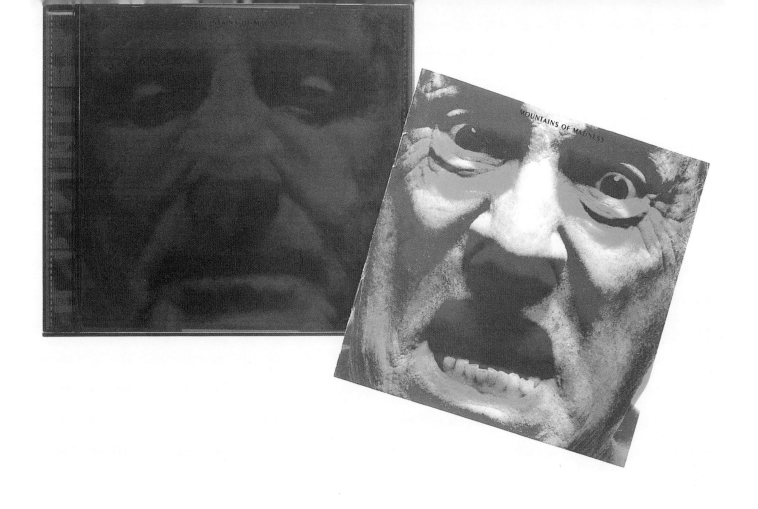

H.P. Zinker CD Cover

DESIGN FIRM Sagmeister Inc.

DESIGNERS Stefan Sagmeister, Veronica Oh

ART DIRECTOR Stefan Sagmeister

PHOTOGRAPHER Tom Schierlite

By placing all of the red/green images on one side of the printed sheet, designers saved printing costs by avoiding a 4-color on 4-color run. The compact disc itself was printed 2-color.

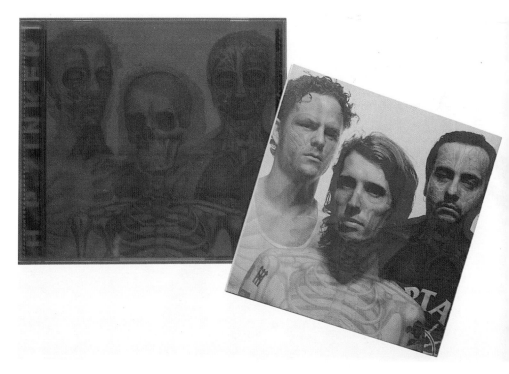

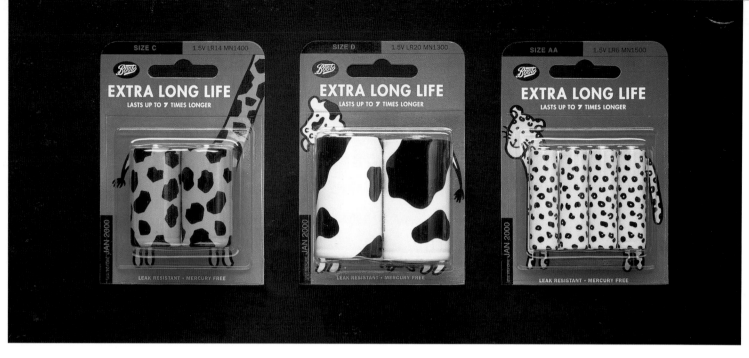

DESIGN FIRM Lewis Moberly
ART DIRECTOR Mary Lewis
DESIGNER/ILLUSTRATOR Shaun Bowen
CLIENT The Boots Company Place
PRODUCT Children's batteries

Boots Batteries is a range of batteries targeted at children. The brand aims to extend gift buying (they are positioned in the store next to children's gifts) and build loyalty to this growing sector. The packaging features different animals whose bodies become the batteries themselves.

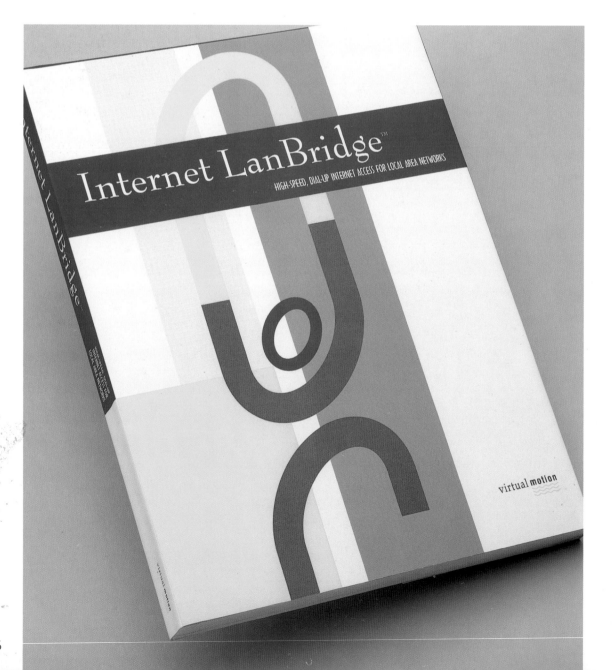

DESIGN FIRM
Graef & Ziller Design
ART DIRECTOR
B. Ziller
DESIGNER/ILLUSTRATOR
Andrew Richards
CLIENT
Virtual Motion
PRODUCT
Software
TECHNIQUE
Offset

The box was primarily designed to be sent to Original Equipment Manufacturers (OEMs) with modem hardware. It was also being used for consumer packaging, so the design needed to stand out in a software catalog. The art was created in Adobe Illustrator and printed in five PMS colors on a direct digital Heidelburg press.

DESIGN FIRM Raziya Swan
ART DIRECTOR Alice Dreuding
DESIGNER Raziya Swan
ILLUSTRATOR Raziya Swan
PHOTOGRAPHER Del Ramers
CLIENT/STORE Baby Giraffe African Imports
PAPER/PRINTING Pantone uncoated

*The Adobe Illustrator-designed logo is
applied to bags by hand, using cut paper
and Identicolor transfers.*

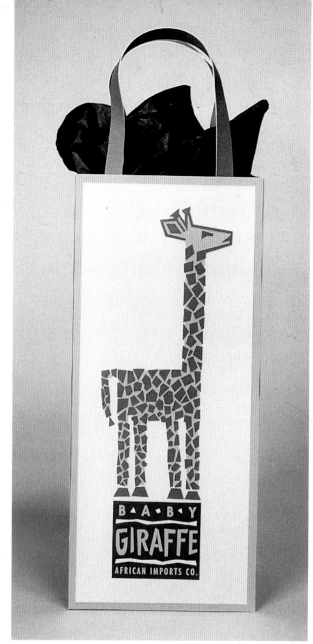

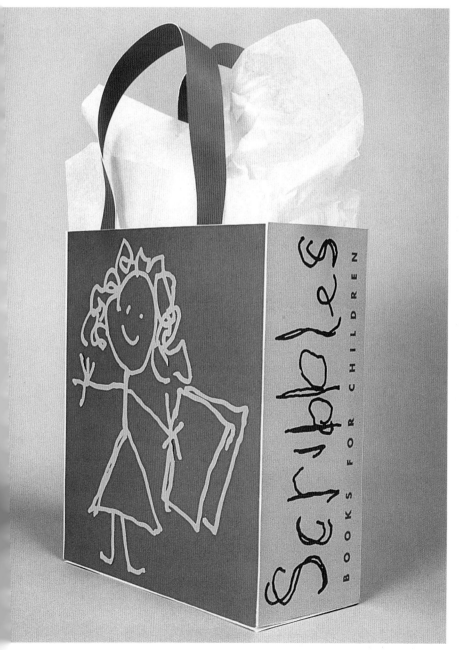

DESIGN FIRM Raziya Swan
ART DIRECTOR Alice Dreuding
DESIGNER Raziya Swan
ILLUSTRATOR Raziya Swan
PHOTOGRAPHER Del Ramers
CLIENT/STORE Scribbles, Books for Children
PAPER/PRINTING Pantone uncoated red, blue,
and yellow

*After scanning the hand-drawn stick figure and the word
"Scribbles," the bag was constructed by hand, using cut
paper and Identicolor transfers set in QuarkXPress.*

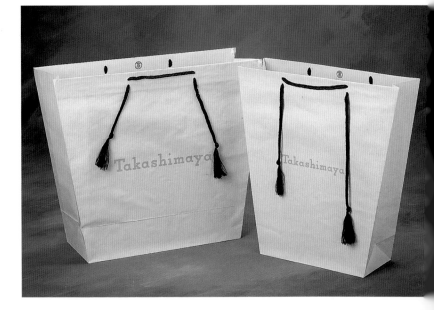

DESIGN FIRM Susan Slover Design
CLIENT/STORE Takashimaya
BAG MANUFACTURER Keenpac North America Ltd.
DISTRIBUTOR Image Packaging Inc.

DESIGNER Ron Raznick
CLIENT/STORE Rubenstein Bros., New Orleans
BAG MANUFACTURER Keenpac North America Ltd.
DISTRIBUTOR RTR Packaging

DESIGN FIRM Lewis Moberly
ART DIRECTOR Mary Lewis
DESIGNER Paul Cilia La Corte
ILLUSTRATOR Geoff Appleton
CLIENT Askeys
PRODUCT Cup Cornets

The design's focus is on the pleasure aspect of ice cream while evoking happy childhood memories. The packaging has dual merchandising, which means it can be displayed as a portrait or landscape. The bright bold posterised imagery links up on a shelf to create a continuous Askey's world.

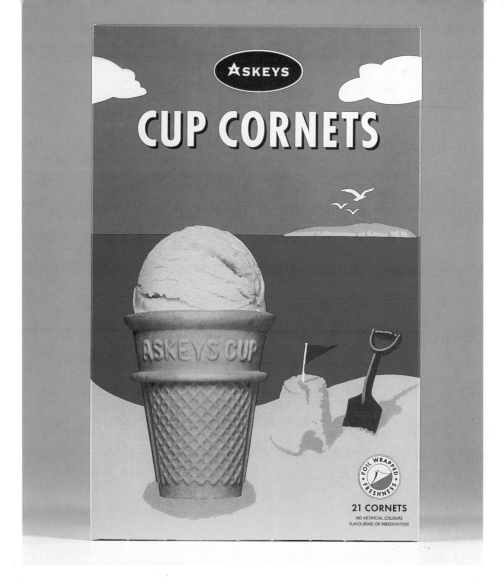

DESIGN FIRM Sayles Graphic Design
ALL DESIGN John Sayles
CLIENT Hickory Pit
PRODUCT Hickory Pit Barbecue Sauce
TECHNIQUE Offset

These labels feature the designer's original graphics with warm colors that stand out in retail displays. The restaurant's distinctive logo, also designed by Sayles, is wrapped in flames and smoke, reminiscent of a rotisserie grill. Additional graphics on the label are illustrated in the same style.

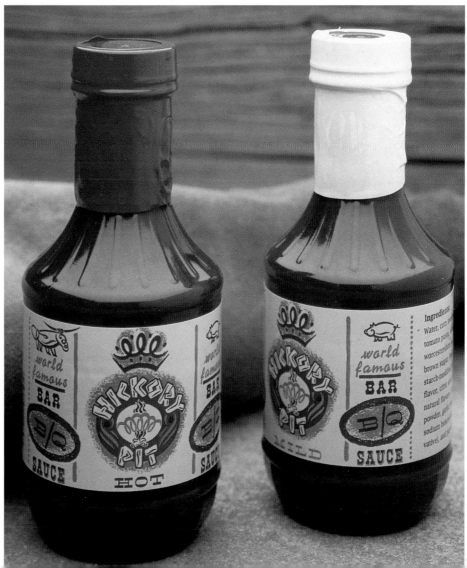

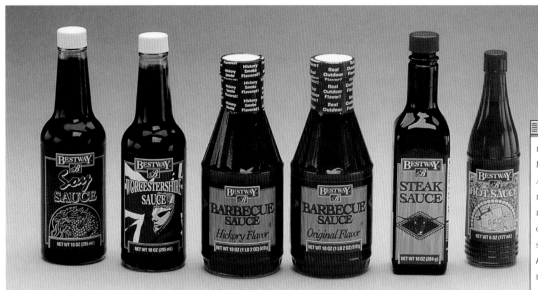

Product

DESIGN FIRM

Marketing Management, Inc.

ART DIRECTOR Stuart Simpson

DESIGNER/ILLUSTRATOR Roger Higgins

PROJECT Bestway sauces

CLIENT MMI/Jewel-Osco

SOFTWARE

Adobe Illustrator, Adobe Photoshop

HARDWARE Macintosh Power PC

Bestway sauces are part of a first-
quality store brand program. The full line
was constructed in Illustrator from hand-
drawn sketches with background
textures produced in Photoshop.
Final output is four-color process
lithography/flexography.

Product

DESIGN FIRM

Marketing Management, Inc.

ART DIRECTOR Stuart Simpson

DESIGNER/ILLUSTRATOR John Horacek

PROJECT Bestway soda

CLIENT MMI/Jewel-Osco

SOFTWARE Adobe Illustrator

HARDWARE Macintosh PPC

Bestway soda is part of a first-quality
store brand program. The full line was
constructed in Illustrator from hand-
drawn sketches with background
textures produced in Photoshop.
Final output is four-color process
lithography/flexography.

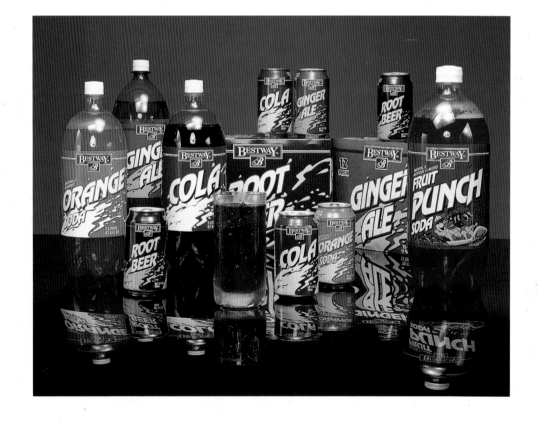

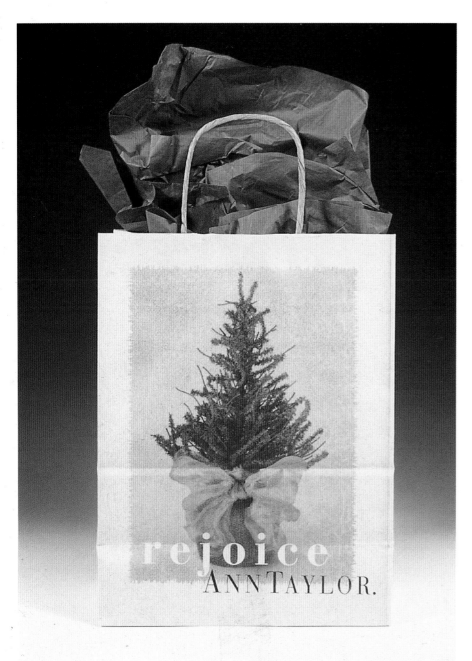

DESIGN FIRM Desgrippes Gobé and Associates
ART DIRECTOR Peter Levine
DESIGNER Kim Tyska
PHOTOGRAPHER François Halard
CLIENT/STORE Ann Taylor/Holiday 1994
BAG MANUFACTURER Wright Packaging
PAPER/PRINTING Bleached, recycled kraft paper

The client wanted an image suggesting "holidays,"
without referring to Christmas; the firm designed a
shopping bag that depicts a pine tree, without adding
the specific elements of Christmas.

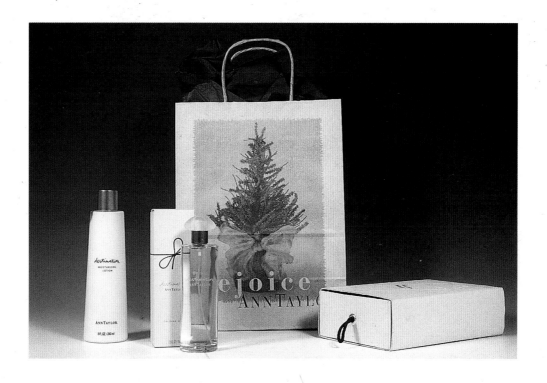

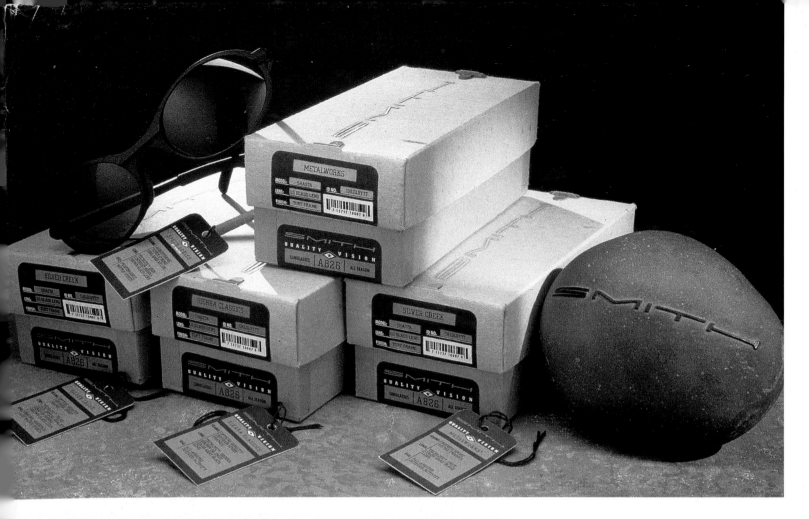

DESIGN FIRM Hornall Anderson Design Works
ART DIRECTOR Jack Anderson
DESIGNER Jack Anderson, David Bates
CLIENT Smith Sport Optics, Inc.
PRODUCT Sunglasses

The strategy here was to capture the pureness of the outdoors in the merchandising of the company's products and to differentiate the company from its competitors. Natural materials were blended with the actual construction technology and branded with the Smith identity. Old-fashioned metal fasteners and tape are exposed, creating an honest presentation for the packaging.

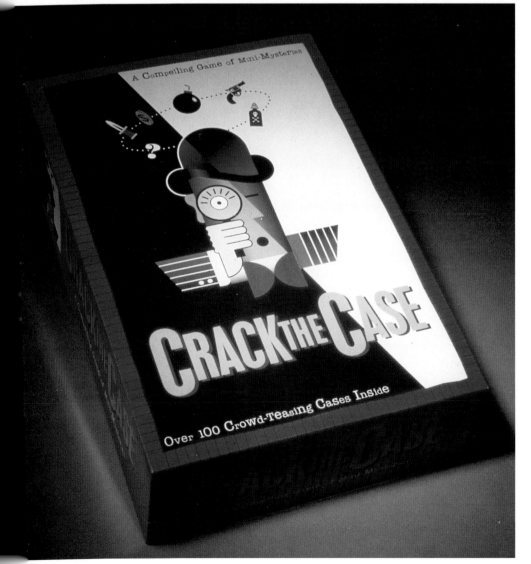

DESIGN FIRM Sibley-Peteet Design
ART DIRECTOR Jim Bremer, David Beck
DESIGNER/ILLUSTRATOR David Beck
CLIENT Milton Bradley
PRODUCT Game
TECHNIQUE Offset

"Crack the Case" is an adult party game based on different crime solving scenarios. The initial pencil sketches were scanned, and the final art was done in Adobe Illustrator.

For more work by these designers and others, please see the following titles, also by Rockport Publishers:

The Best Direct Response Design
The Best Invitation, Card, and Announcement Design
The Best Music CD Art and Design
Breaking the Rules in Graphic Design
Designing Identity, by Marc English
Digital Design
Graphic Design on a Limited Budget
Package & Label Design
Shopping Bag Design 2